THE LITTLE

Vuillard

Alyse Gaultier

*To my parents Fabienne and Jean-Pierre Gaultier,
my friend Karim A. Soumaïla
and my sister Clémentine Gaultier.*

Flammarion

C O N T

Alphabetical Guide

The alphabetical entries have been classified according to the following categories. Each category can be identified by its color code.

■ Vuillard's World

Antoine, André
Bernheim-Jeune
Bonnard, Pierre
Condorcet, Lycée
Denis, Maurice
Exhibitions
Fort, Paul

Hessel, Jos
Journal
Lugné-Poe
Mallarmé, Stéphane
Natanson (Brothers)
Proust, Marcel
Ranson, Paul

Revue blanche, La
Roussel, Ker Xavier
Sérusier, Paul
Studios
Travels
Vallotton, Félix

■ Inspiration

Academies
Gauguin, Paul
Hessel, Lucie
Impressionism
Japonism
Louvre

Mother (Madame Vuillard)
Natanson, Misia
Neo-Impressionism
Paris
Photography
Pont-Aven, School of

Puvis de Chavannes, Pierre
"Society"
Symbolism
Talisman, The
Theater

■ Subject matter and works

Anabaptists, The (Les Anabaptistes)
Decorative Arts
Decorative Panels
In Bed (Au lit)
Intimisme
Landscapes
League of Nations, Geneva
Nabis

Nudes
Palais de Chaillot
Printmaking
Programs (for the theater)
Public Gardens (Jardins publics)
Realism
Self-Portraits
Sets and Scenery

Society Portraiture
Still Life
Théâtre des Champs-Élysées
Walk in the Port, The (La Promenade dans le port)
Yvonne Printemps and Sacha Guitry

The alphabetical entries are cross-referenced
throughout the text with an asterisk (*).
All works reproduced are by Édouard Vuillard unless otherwise indicated.

THE STORY OF ÉDOUARD VUILLARD

PROLOGUE

Undemonstrative, self-effacing even, Édouard Vuillard declared: "I was always only a spectator." An exploration of his work, however, takes one on a very interesting journey. His story is a record of the sometimes difficult experiences of an impassioned and demanding artist as they delve into the mysteries of reality. At the forefront of the avant-garde from 1890 to 1900, his work during this decade would amount to an entire career for many artists. In these years, he was much sought-after by the more progressive theaters* and by the anarchist press, and he developed a talent as a decorative painter that he continued to exercise, notably at the Palais de Chaillot* [1937] and the League of Nations* in Geneva [1938]. Later shifting increasingly to Realism*, his oeuvre is essentially a magnificent tribute to the lifestyles of a long-forgotten world.

Born November 11, 1868, to a lower-middle-class family, Édouard spent his childhood in Cuiseaux, a small town in Saône-et-Loire, in the Burgundy region. He was the son of Marie, née Michaux; and Jean Honoré Vuillard, retired navy captain turned tax collector; and the younger brother of Marie, a future dressmaker; and of Alexandre, who would make a career in the army. Upon his father's retirement in 1877, the family settled in Paris. By 1879, his mother* was running a corset store near the Opéra, which, following her spouse's death in 1883, she transferred to her house on rue Saint-Honoré. Still a youth at the time, Édouard, whose early schooling was at the Rocroy-Saint-Léon school of the Marist brothers, now benefited from more progressive teaching at the Lycée Condorcet*, a high school attended by the children of well-off families. He there forged friendships with Roussel* in 1883 [whose father was a doctor and art enthusiast], then with Denis* and future theater director Lugné-Poe*. Édouard's grades were excellent and he may have taken part in the plays the school produced annually. However, "his school books and other documents of the time show that he was constantly doodling and sketching" [Thomson, *Vuillard*].

Having first made up his mind to prepare for the Saint-Cyr military school on leaving the *lycée* in 1885, Vuillard eventually joined Roussel in the studio of the academic painter Maillart. Enrolled in the master's courses at the École des Gobelins, he

Female Nude Seated in an Armchair [Femme nue assise dans un fauteuil], c. 1905. Oil on cardboard, 24 ¾ x 21 ¼ ins (63 x 54 cm). Crane & Kalman Gallery, London.

Vuillard at the
Natanson's in
Villeneuve-sur-
Yonne, 1898.
Private collection.

made copies after works from antiquity. A Neoclassical work
dating from as early as 1885, *The Death of Cesar* [*La Mort de
Cesar*], already reveals an awareness of the theatrical. Unsuccess-
ful in his first application to the École des Beaux-Arts, he regis-
tered at the Académie* Julian in 1887, where, with the intention
of taking the entrance examination again, he worked from live
models and Old Masters. Accepted at the Beaux-Arts in 1888,
he studied in the studio of the already celebrated Jean-Léon
Gérôme, producing derivative nude* studies [*Nudes*, 1888].

Even at this time, Édouard was furthering his education out-
side of school. It is clear from the sketches and notes in the jour-
nal* he was beginning to keep that he was already interested in
the stage, particularly in the supernatural spectaculars fashion-
able at the time. He regularly went to the Louvre*, where he
was especially receptive to eighteenth-century French [Chardin,
Watteau, Le Sueur] and seventeenth-century Dutch painting
[Rembrandt, Vermeer]. He executed still lifes* in the subtle
tones of Chardin (*Still Life with Salad* [*Nature morte à la salade*],

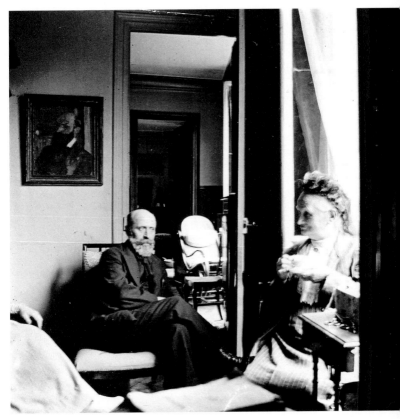

1888) and self-portraits* committed to honesty in the manner of Rembrandt and Vermeer [*Portrait of the Artist*, c. 1889]. While displaying Naturalist leanings in his intimate works, he would soon find himself in the midst of a circle of artists inspired by Symbolism*, leading him to embark on a quest for a radically different manner of apprehending the real.

Vuillard and his mother, Rue de Calais, c.1922–1924. Private collection.

ACT I : NABISM 1889–1900
From the autonomy of the subject to its poetry

In an attempt to break with Academic art, the artists Denis, Bonnard*, Ranson*, and Henri-Gabriel Ibels gathered around Sérusier* after he had come back from Pont-Aven* in October 1888 with *Landscape in the Bois d'Amour* [*L'Aven au Bois d'amour*], a work executed under instructions from Gauguin*. Inaugurating the autonomy of painting with respect to the real, this work was proclaimed as *The Talisman** by the brotherhood of painters that the poet Cazalis soon baptized «Nabi*,» from a Hebrew word meaning "prophet." At the time a Naturalist, Vuillard—who surely must

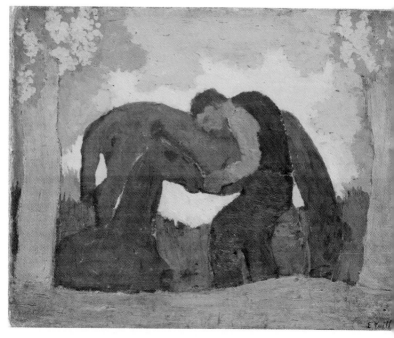

Man with Two Horses (L'Homme et les deux chevaux), c. 1890. Oil on cardboard, 10 ¾ x 13 ¾ in. (27.5 x 35 cm). Josefowitz Collection, Lausanne.

have seen the exhibition of the Impressionist* and Synthetist Group at the World Fair in 1889—also became interested in Gauguin's aesthetics, having met the "prophets" themselves at the Académie Julian in the same year. Attracted by their idea of an art "for the future," he rallied to the cause via Denis, later meeting Bonnard and Sérusier and becoming known as the "*Nabi zouave*" because of his red beard. At this time he was also attending gatherings at the "Temple"—Ranson's studio—and showing growing enthusiasm for the arts of Japan.

In 1890, under the influence of Denis and Sérusier, he abruptly abandoned the imitation of nature. In accordance with the ideas of the movement's theorist, Denis ("Remember that a canvas, before it is a naked woman, a war-horse or some anecdote or other, is first of all a plane surface to which colors assembled in a certain order are applied" [*Art et critique*]), he began a series of experiments with the aim of establishing the supremacy of the plastic value of a painting over the subject represented. These efforts culminated in his painting *In Bed* [*Au lit*,1891]. The upshot of his adherence to the methodical aesthetics of his friends was an intellectual approach to reality that lay halfway between the spiritual conceptions of Sérusier and the sensualist attitude of Roussel. He thereby outstripped his colleagues by breaking definitively with the illusionist representation

of space and of the figure. No less sensitive than Proust* to the reso-
nance he felt in domestic environments, he forsook Gauguin's
Symbolism and turned back to his immediate surroundings—to
his mother [with whom he would live until she died] and her work-
shop and dressmakers. Starting off from Synthetism (*Portrait of
Ker-Xavier Roussel*, known as *The Reader* [*Portrait de Ker-Xavier
Roussel, dit Le Liseur*], c. 1890–1891) and Pointillism (*Grand-
mother at the Sink* [*La Grand-Mère à l'évier*], c. 1890–1891),
Vuillard forged a personal technique better adapted to exalt a world
swathed in dresses and bolts of cloth. Initially, he would align dots
of pigment derived from Seurat's points over the wallpaper lining a
studio (*Woman with Pink Wallpaper* [*Femme au papier peint
rose*], 1895), but they soon became the ornamental motifs on a
dressmaker's frock (*The Floral-Patterned Dress* [*La Robe à
ramages*], 1891). This reintroduction of real though notably orna-
mental objects differentiates his art from that of Sérusier and Denis.
Less receptive to Gauguin than these brother-artists, Vuillard was

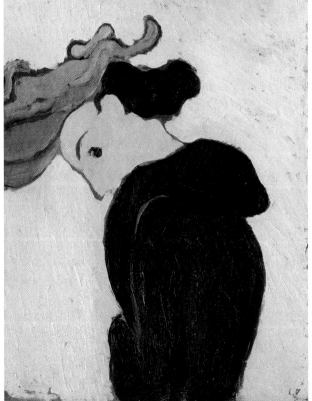

*Profile of a Woman
in a Green Hat*
(*Femme de profil au
chapeau vert*),
c. 1890–1891.
Oil on cardboard,
8 ¼ x 6 ¼ in.
(21 x 16 cm).
Musée d'Orsay,
Paris.

nonetheless Symbolist in spirit, albeit of a specific type, closer to the ideas of Mallarmé*. He shared with the poet an impulse to paint the effect produced by figures rather than the figures themselves, and he preferred to suggest rather than to describe, an approach that suffuses his works with a feeling of poetry [*Misia and Thadée Natanson,* c. 1897]. All the same, as Guy Cogeval has pertinently observed, some of the *intimiste* [see *Intimisme*] works, with their enclosed and sometimes distressing atmosphere, can recall the plays put on at the Théâtre de l'Oeuvre. This is the case in *The Artist's Mother and Sister* [*Mère et sœur de l'artiste,* c. 1893], in which the figures are crushed beneath the sheer weight of decoration, and also in *Dinner Time* [*L'Heure du dîner,* c. 1890–1891], in which the figures seem gripped by a drama reminiscent of a Maeterlinck play. It was during these years that the artist was heavily involved in avant-garde theater.

From the Théâtre-Libre to the Théâtre de L'Oeuvre

The Nabis, in addition to concentrating on the value of a picture in and of itself, also aimed to abolish the frontiers separating art from life and to extend the pictorial domain to include such areas as the graphic, decorative*, and theatrical arts. "Of all of them, the one who from the outset showed the most pronounced interest in the theater, and the one who gave the best all-around advice, was Édouard Vuillard," noted Lugné-Poe [*La Parade I*]. Indeed, sketches of boxes at the theater in his journal dating from 1888 attest to the artist's early curiosity about the world of the playhouse. It was, moreover, through Lugné-Poe that he met his earliest buyer, the famous actor Coquelin Cadet, for whom he carried out a series of portraits [*Coquelin Cadet,* c. 1890]. Beguiled by a plan to set up a sort of amateur company, the Théâtre des Marionnettes, in Ranson's studio, together with the Nabis, Vuillard was soon dealing with most of the decor, particularly at the time of the production of Maeterlinck's *Seven Princesses* [*Sept Princesses*] in 1892. In the same spirit, from 1896 to 1898, the Nabis were to put on productions for the Théâtre des Pantins in the apartment of the composer Claude Terrasse.

Through Lugné-Poe, with whom he shared a studio on rue Pigalle in 1891, Vuillard and the Nabis met the founder of the Théâtre-Libre*, André Antoine*, the first director to commission illustrated programs* from the painters. In keeping with the Naturalist style of his company, however, Antoine felt greater affinity with the figurative

Nabism of Ibels than with Vuillard's Symbolism, taking on few of his propositions [*Le Cuivre* by Adam and Picard, 1895]. Vuillard's manner was better suited to that of the Théâtre d'Art, founded by Paul Fort*. With other "prophets," he produced playbills [*Le Concile féerique*, 1891] that appeared in the review of the same name, as well as "Synthetist decorations" at the director's behest. This experience culminated in the Théâtre de l'Oeuvre, which Vuillard set up in 1893 with Camille Mauclair and Lugné-Poe. The name was Vuillard's choice—he came across the word "oeuvre" by chance in a book—and he reigned supreme in the company until 1895, execut-

Théâtre de l'Oeuvre poster for *Beyond Human Might* by Bjornson, 1894. Lithograph, 12 x 9 ¼ in. (30.2 x 23.5 cm). Josefowitz collection, Lausanne.

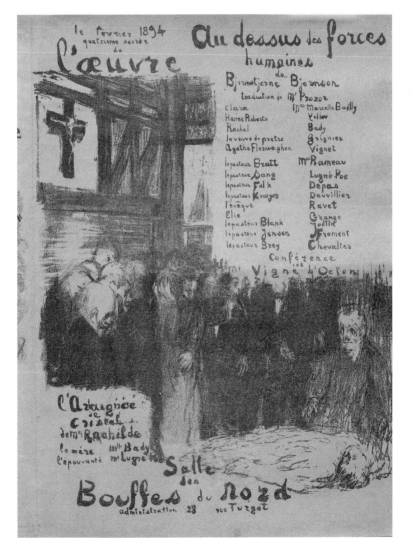

ing the majority of the sets and scenery* as well as the programs for plays by authors such as Maeterlinck, Ibsen, Beaubourg, Hauptmann, and Björnson.

It would prove to be a crucial collaboration, as much for the theater as for his art, both at the time and in the future. On the one hand, the theater projects of Vuillard and the Nabis mark the onset of an era in which painters became involved in the performing arts, which renewed the art of stage design with groundbreaking sets that were taken up again in productions by later avant-garde companies beginning in the 1920s. On the other hand, this theatrical world, in addition to haunting the pictures he was then painting, compelled him to address new, more dramatic subjects in his programs. More generally, his training as a set-designer continued to inform his artwork, particularly when it came to portraying the bourgeois residences of the new patrons he encountered through his links with the literary press.

From the world of La Revue blanche to the Natansons' circle

It was once more by way of a man of the theater, Pierre Veber, a friend from the Lycée Condorcet, that Vuillard met the Natanson* brothers in 1891, shortly after they had founded *La Revue blanche*. With their penchant for the arts, they encouraged the graphic talents of many painters, hiring them to illustrate essays on art by Stéphane Mallarmé, Tristan Bernard, Romain Coolus, Jules Renard, and occasionally Marcel Proust and Guillaume Apollinaire. Captivated by the art of the Nabis, and more specifically by Vallotton*, Bonnard, and Vuillard, the editor of the arts page, Thadée Natanson, published Vuillard's debut lithograph in 1893: *Interior* [see Printmaking]. Vuillard, who participated with the Nabis in the exhibitions in Le Barc de Boutteville gallery from 1891, now contributed to those held on the review's premises, his first one-man show taking place in 1892.

Vuillard became friends with his art-loving employers and was regularly to be found in Thadée's house, La Grangette, near Fontainebleau, where he met Redon, Seurat, and Mallarmé. He was fascinated by Thadée's wife Misia Natanson*, a talented pianist exalted by many avant-garde artists; from 1894, she was to become Vuillard's second muse, capturing his heart. Moving on from the celebration of the lower-middle-class interiors of his mother's home (*Woman in front of a Cupboard* [*Femme au placard*],

c. 1895)—through the inspiration of Misia and by a novel treatment à la Nabis—he now distilled the more bourgeois world he frequented in the Natansons' apartment on rue Florentin (*Interior: Natanson with Misia at the Piano* [*Intérieur: Natanson avec Misia au piano*], c. 1897) or in their residence at Le Relais, Villeneuve-sur-Yonne [*Misia at Villeneuve-sur-Yonne*, c. 1897]. Discovering new subjects in this realm, he was soon commissioned to adorn the walls of mansions belonging to many members of the family, creating several decorative ensembles [the Desmarais panels, 1892; the residence of Thadée Natanson in 1895; that of Adam Natanson in 1899; *Public Gardens**, 1894]. Sometimes including folding screens, these designs, which mark the beginning of a long sequence, are evidence of Vuillard's newfound interest in the decorative arts. In 1895, he designed a series of earthenware plates and a project for stained glass (*Chestnut Trees* [*Les Marronniers*], c. 1894) for Siegfried Bing's Paris gallery, La Maison de l'Art Nouveau.

Misia Natanson in front of the Credence Table, Rue Saint-Florentin, 1899. Silver gelatin print (vintage), 3 ½ x 3 ½ in. (9 x 9 cm). Private collection, Paris.

15

Now a veritable designer, Vuillard thus actively contributed to overcoming the frontiers between fine and applied arts. Strictly adhering to Denis's principles advocating autonomy in painting, Vuillard numbers among those Nabis who broke most radically with representation in the academic sense. Not being theoretically minded, he sought an intuitive approach, a judicious attitude that prepared his talent for his seminal subject—the *intimiste* scene—and thus prefigured his desire to regain contact with the world of objects.

The upheaval occasioned by Fauvism, Cubism, and abstraction—though he had been on the fringes of them all—proved beyond Vuillard. He was, like the Nabis, a forerunner of the "return to order" that took on such significance after the First World War. But this time, rather than following Sérusier and Denis and tackling religious or mythological themes, Vuillard, keeping to his own path, chose to focus this return to classic norms on his immediate

Madame Hessel Sitting in the Garden at the Clos Cézanne (Madame Hessel assise dans le jardin du Clos Cézanne), 1920–1925. Oil on canvas, 18 x 32 in. (45.5 x 81.5 cm). Private collection.

surroundings. Though criticized after his death by those who looked back nostalgically to his early period, it was this phase—rich in fresh experiments and centered on a new social environment—that led to his consecration as an artist.

ACT II : RETURN TO THE REAL 1900–1940
From Bernheim-Jeune to life near Lucie Hessel

Just as Thadée and Misia Natanson were associated with his creations from 1890 to 1900, from 1900 through 1940 it was the art dealer Jos Hessel* and his wife Lucie*, daughter of a wealthy draper, who influenced the painter's new direction. Vuillard met the couple shortly before 1900 through Vallotton. As an employee and later co-director of Bernheim-Jeune*, Jos introduced the painter to the gallery, where he exhibited regularly from 1900 to 1913. An Impressionist stronghold, the gallery quickly awakened Vuillard's interest in the movement, as can be seen in many interiors

(*The Fireplace* [*La Cheminée*], 1906) and—a typical Impressionist specialty—in numerous plein air landscapes*.

Accompanying the Hessels on their travels* around Normandy and Brittany, the countryside he encountered inspired him to try out the subject matter of Boudin, Monet, and Caillebotte in descriptively rendered views of an Impressionist stamp (*The Game of Checkers at Amfreville* [*La Partie de dames à Amfreville*], 1906). Often composed from photographs, these scenes are further evidence of his drive to acquire a more mimetic approach to reality (*The Tree-Lined Avenue*, [*L'Allée en sous-bois*], 1907–1908; *The Haystack* [*La Meule*], 1907–1908), even if, in some seaside views, the two-dimensionality characteristic of his Gauguin phase reappears (*The Walk in the Port*,* [*La Promenade dans le port*], 1908).

Following the collapse of *La Revue blanche*＊ in 1903, Lucie gradually replaced Misia, eventually becoming very close to the painter. If the artist's journal gives little hint as to his true feelings for Madame Hessel, the turbulent nature of their relationship is obvious. The diary abounds with notes like "telephone Lucie not pleased," or "reproach myself with my cowardice with respect to Lévy"—in particular in 1914, a year in which he became involved with the actress Lucie Ralph, with whom he seems to have had a liaison. Still, under the influence of his new muse, he carried on painting in an *intimiste* vein in the Hessels' apartments on rue de Rivoli, then on rue de Naples, and in the house at Vaucresson and at the Château de Clayes (*Mme Hessel Lying on a Couch* [*Mme Hessel étendue sur le divan*], c. 1920). If Misia is merely hinted at in her bourgeois surroundings, Lucie is portrayed as increasingly corporeal. Visiting the fashionable Hessels almost daily, he also made new acquaintances who would soon turn into patrons.

From society portraiture to Proust's madeleine

Leaving the anarchistic world of *La Revue blanche*, Vuillard, through the good standing of his new sponsors, now met regularly with leading figures from the worlds of finance, medicine, politics, literature, and the theater, as well as with many aristocrats. From 1900 through 1913, many exhibitions including his work were held at Bernheim-Jeune, a gallery by now enjoying a glowing reputation, while his contributions to the Salon d'Automne and the Salon des Indépendants received lavish praise. A recognized figure, from 1912 on, wealthy art lovers keen to invest in a sure bet (*Theodore Duret in His Study*

[*Théodore Duret dans son bureau*], 1912) welcomed him with open arms. Although initially a stranger to this affluent and gregarious milieu, he steadily, beneath Lucie's wing, made his way in society*, eventually becoming its representative painter. Besieged by commissions, he devoted the lion's share of his time to this activity between 1920 and 1940. Though now released from the commercial constraints of having a dealer, there were repercussions: Vuillard increasingly found himself acceding to the more conventional tastes of new clients who wanted to recognize themselves in their portraits. Thus the faintly sketched silhouettes typical of the Nabis period are supplanted by more readily identifiable likenesses [*Portrait of Jeanne Lanvin*, c. 1933]. He was, however, less accommodating than some portraitists of his time [such as Jacques Émile Blanche], once remarking: "I don't make portraits; I paint people where they live." Now more attentive to spatial depth, he scrutinized every detail of the rooms in which his models sat. Several observations he makes imply that this was a means of stripping bare his patrons' personalities. By concentrating especially on artworks, textiles, and wallpapers in the new world in which he found

The Forecourt of Château-Rouge at Amfreville. Private collection.

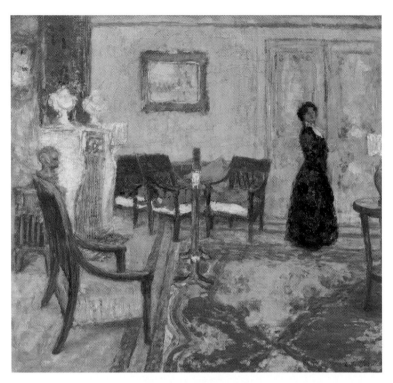

Woman in a Room (Femme debout dans un salon), c. 1905. Oil on cardboard, 23 ½ x 26 ½ in. (60 x 67 cm). Private collection.

himself, he resumed his quest for an equivalent of Proust's *madeleine* [*David-Weil*, c. 1930; *Princess Bibesco*, 1935].

A few portraits of artists painted in their workplace are of a less finished and fussy appearance, such as the preparatory sketches for a commission from the City of Paris for a series of *The Anabaptists** [*Les Anabaptistes*], showing Aristide Maillol, Bonnard, Roussel, and Denis—though the final versions are highly polished. A further example is the splendid series inspired by Sacha Guitry's play, *L'Illusionniste,* in which the actors' outlines (*Yvonne Printemps Seen from the Wings* [*Yvonne Printemps vue des coulisses*], 1922), no more than sketched and then dropped into an unreal space (*De Gardey the Dwarf* [*Le Nain de Gardey*], 1922), recall the energetic brushwork of the Nabis period.

Thus, it seems that, by reverting to the descriptive, Vuillard was not only fulfilling his new patrons' expectations, but also responding to a need that can be sensed in the majority of artists for a "return to order" as it asserted itself shortly after the war. After 1930, however, this change of direction became still more radical, seemingly corresponding to a personal imperative: the

death of his mother in 1928. Painstakingly rendering the paintings and silks in his patrons' interiors, it is rather as if, by straining to regain a glimpse of the reproductions of masterpieces that graced the walls of his boyhood room or the dressmaking workshop, he was also striving to make a past, forever lost, live once more.

From decoration to consecration

Solicited by a well-heeled clientele, from 1899 to 1922 Vuillard fulfilled many private commissions for decorative panels*, although the experimental formats, techniques, and handling foretold of the artist's new ambitions. The final Nabis ensemble realized for Adam Natanson was already of gigantic dimensions (*First Fruits* [*Les Premiers fruits*], 14 ft. 2 in. x 7 ft. 11 in. [431 x 243 cm]; *Window Giving on to a Wood* [*Fenêtre donnant sur le bois*], 12 ft. 5 in. x 8 ft. 2.11 in. [378.5 x 249.2 cm], 1899) and treated in a manner close to that of the tapestries he had seen in the Musée de Cluny. For the next series [of still large, if more manageable, dimensions] Vuillard reverted to the use of pigment mixed with hot glue, a process he had learned while painting set decorations, by which he attained a matte effect worthy of Puvis de Chavannes* himself. The panels for Henry Bernstein and the Princes Emmanuel and Antoine Bibesco—which reveal an exploration of the work of

Pierre Bonnard, Édouard Vuillard and the Prince Antoine Bibesco on the train from Cordoue to Bobadilla. Citrate print. Musée d'Orsay, Paris.

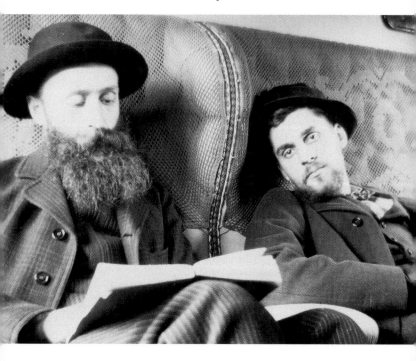

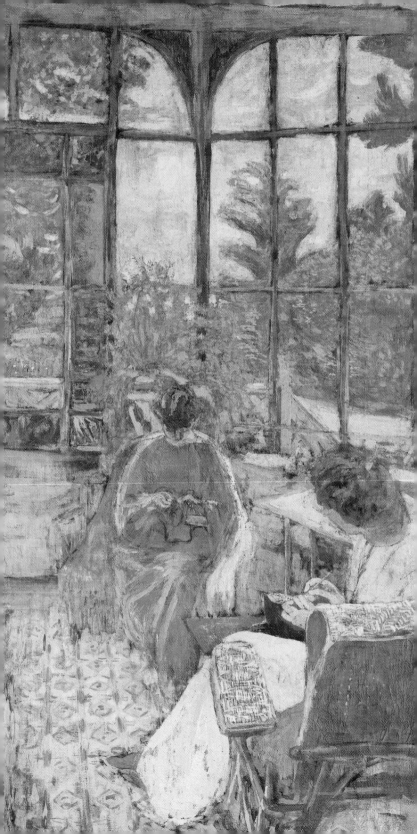

Caillebotte and, especially, Monet (*Paris Streets* [*Rues de Paris*], 1908; *The Tree-Lined Avenue* [*L'Allée en sous-bois*] and *The Haystack* [*La Meule*], 1907–1908)—are a case in point, as are the magnificent and similarly Impressionistic decorations installed in the Bernheim-Jeune villa at Villers-sur-Mer (*The Veranda at Loctudy, Brittany* [*La Véranda à Loctudy en Bretagne*], 1912).

Vuillard, in mastering the technique of tempera over large expanses, now attained the apogee of his activity as a decorator. In 1913, he was asked to undertake the decoration of a public building: the Théâtre des Champs-Élysées*. For the foyer of the theater with which he was entrusted, Vuillard took inspiration from, among other things, popular plays such as *Le Petit café* and *Le Malade imaginaire*, evidence of a new interest in comedy. If the Champs-Élysées project was already more traditional in treatment, more classical still is *At the Louvre** [*Au Louvre*, 1921–1922], a series for a private patron, which pays homage to France's artistic heritage. If high society had already chosen Vuillard as its favorite portraitist, the painter now attained nationwide fame. Having refused the Légion d'honneur, in 1937 he accepted a chair in the Institut. Rather late in the day perhaps, the government then commissioned him to decorate the Palais de Chaillot (*Comedy* [*La Comédie*], 1937) and the League of Nations in Geneva (*Peace Protecting the Muses* [*La Paix protectrice des Muses*], 1938). Although now quite old, the artist created for the first time allegories that hark back to masters such as Puvis de Chavannes and Le Sueur. Here, in a clear break with preceding works, he seems once again on the verge of changing directions.

EPILOGUE

Most of the works of this period were unveiled at the retrospective in the Pavillon Marsan in 1938. In 1940, racked by disease, Vuillard abstained from going with the Hessels to their retreat in the west of France. Fearing an attack by the German army, he stopped over in La Sarthe at Monsieur Daber's, then, faced with a hail of shells, finally agreed to proceed to La Baule. When he died, of a pulmonary edema, on June 21, 1940, Lucie was at his bedside. Édouard Vuillard lies buried in the cemetery at Batignolles, Paris.

Facing page:
The Veranda of the Coadigou at Loctudy (*La Véranda du Coadigou à Loctudy*), 1912. Oil on canvas, 6 ft. 7 in. x 3 ft. 8 ¾ in. (2.01 x 1.135 m). Musée d'Orsay, Paris.

Following page:
Girls Walking (*Fillettes se promenant*), 1891. Oil on canvas, 32 x 25 ½ in. (81.2 x 65 cm). Josefowitz collection, Lausanne.

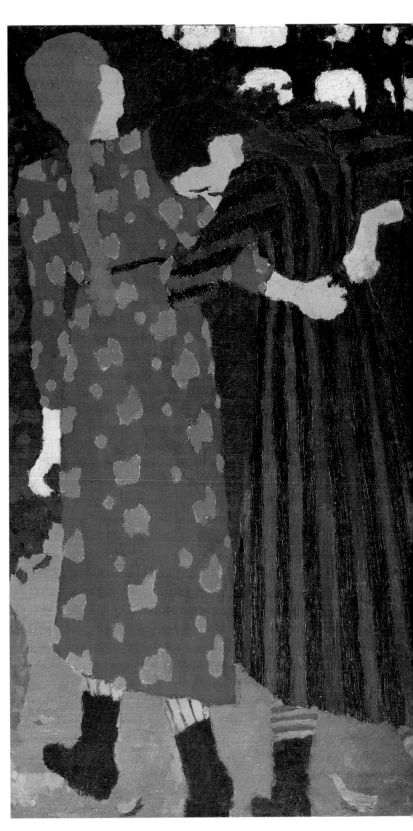

ALPHABETICAL GUIDE

Academies

After Roussel convinced Vuillard not to enter the military school at Saint-Cyr, for a time he trained in the traditional mold with a view to becoming a painter. In 1887, he joined his friend under the unimpeachably academic Diogène Ulysse Napoléon Maillart, a onetime winner of the Prix de Rome who featured frequently in the Salon and who had acquired a reputation in painting circles. The master's lessons were then held in Delacroix's studio on place Furstemberg, though it was while studying with him in the evening at the École des Gobelins that Vuillard worked from live models. By 1888, he was taking courses under the no less academic Léon Gérôme at the École des Beaux-Arts, where he worked from antique sculpture. Proud of having been a student in the studio of this celebrated painter, he was nonetheless influenced crucially by the Dutch and French masters of the seventeenth and eighteenth centuries that he studied every day in the Louvre. In the same year, he registered at the Académie Julian where, in the ambit of the Nabis* movement, dynamic reactions against academic art were underway. From then until 1900, Vuillard made a break with the past, producing a steady stream of

Pascal Adolphe Jean Dagnan-Bouveret, *The Painter and Sculptor Léon Gérôme Shown Wearing the Formal Dress of the President of the Académie des Beaux-Arts*, 1902. Oil on canvas. Musée de Versailles et Trianon, Versailles.

Anonymous, Ernest Marché and his classmates at the Académie Julian, c. 1890. Albumen print. Château-Musée, Nemours.

remarkably modern canvases (*Self-portrait*, c. 1891; *In Bed* [*Au lit*], 1891). Though the turn of the twentieth century witnessed a brief return to Traditionalism, Vuillard neither promulgated theories of art nor evinced any desire to become a teacher or member of a jury. An unassuming, marginal figure, it was more to please his friends than through real conviction that Vuillard later returned to academia, this time as a professor. In 1908, he ran a course at the Académie founded by his friend Paul Ranson*. Then, acceding to a request from Maurice Denis*, around 1934 he joined the post-graduate staff at the Académie des Beaux-Arts on a temporary basis to judge the prestigious Prix de Rome. Amazed by the conscientious manner in which he discharged his duties, Denis, Desvallières, and David-Weil, then members of the Académie des Beaux-Arts, tried to convince him to succeed their confrere, Paul Chabas. After refusing more than once, Vuillard finally took his place at the Institut de France in December 1937.

■ Anabaptists, The (Les Anabaptistes)

While Vuillard was busy portraying members of Paris society*, an official commission from the Ville de Paris (1936) on the occasion of the future World Fair (1937) opened the door to a very different kind of portraiture. This series, comprising four final works

(1923–1937) and models (c. 1930) now housed in the Musée d'Art Moderne de la Ville de Paris, once more harnessed the creative efforts of Vuillard, Bonnard*, Roussel*, Denis*, and Maillol. Entitled *The Anabaptists*, the project, showing the models busy in their workplace, has few links with Vuillard's contemporary works. There are few discrepancies between the maquettes and the final versions, though the former are given a less painstaking handling that gives them an endearing

charm. To portray the personalities of his fellow painters, he placed them in locations they would have felt at home in; and, as if their presence alone is enough to fill the composition with life, they were asked not to pose but just to concentrate on working. Thus Bonnard, who had no love of studios, is captured gazing on a recently completed work (*Panorama at Le Cannet* [*Panorama au Cannet*]), in the company of his basset hound, Pouce. Maillol, whom Vuillard had met at the Académie Ranson*, is depicted in the garden of his workshop at Marly-le-Roi, carving his *Monument to Cézanne* (1912–1929) that was soon to be shown at the Tuileries. Roussel, lost in his vast studio at Étang-la-Ville, seems tormented by the sort of questions that were to haunt Vuillard himself at the end of his life. The palette in the foreground seems to question whether an artist should remain faithful to or sublimate reality, whereas the winter landscape visible through

The Anabaptists, Pierre Bonnard, 1930–1934, reworked 1936–1937. Distemper on canvas, 3 ft. 9 in. x 4 ft. 9 ¾ in. (1.145 x 1.465 m). Musée d'Art Moderne de la Ville de Paris.

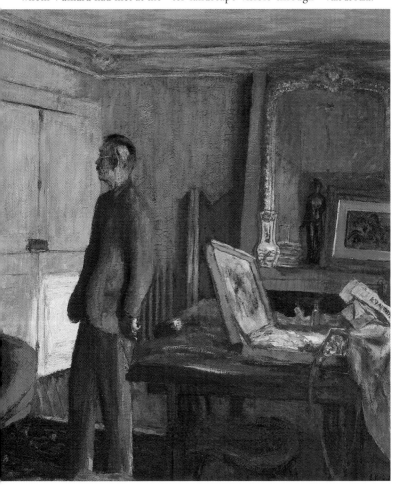

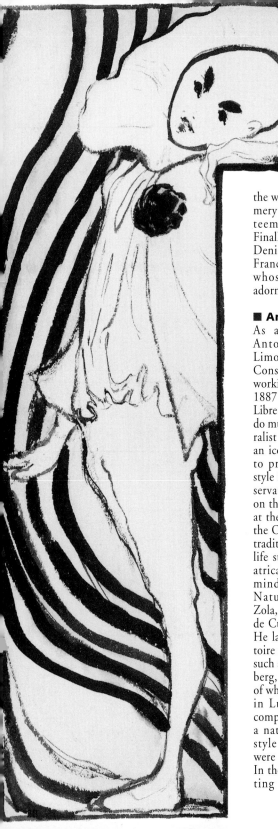

the window jars with the summery look of Roussel's idyll, teeming with nymphs. Finally, the mystically minded Denis is seen decorating the Franciscan chapel at Rouen, whose walls he did indeed adorn from 1929 to 1930.

■ Antoine, André

As a young man, André Antoine, born in 1858 in Limoges, was refused at the Conservatoire, and so began working for a gas company. In 1887 he founded the Théâtre-Libre in Paris, where he was to do much to publicize the Naturalist aesthetic. Something of an iconoclast, he was the first to propose a new theatrical style in opposition to the conservative trends that reigned on the Paris stage, particularly at the Comédie-Française and the Opéra. To break with this tradition, he created a true-to-life style unburdened by theatrical artifice. With this in mind, he turned to French Naturalist authors such as Zola, the Goncourts, François de Curel, and Eugène Brieux. He later broadened his repertoire to include foreign writers such as Tolstoy, Ibsen, Strindberg, and Hauptmann, some of whom also met with success in Lugné-Poe's* Symbolist company. Antoine demanded a natural, unaffected acting style from his players, who were often non-professionals. In the quest for a truthful setting for Fernand Icrès' *Les*

Bouchers, he took the provocative step of placing bleeding lumps of meat on the stage. He worked on various productions with painters with ideas similar to his own, such as Maximilien Luce, Adolphe Willette, and Forain, but also with artists of a very different stamp, such as Signac and Toulouse-Lautrec. Though having little sympathy for avant-garde art, Antoine met—through his collaborator Lugné-Poe—Nabis such as Sérusier*, Vuillard, Bonnard*, and, the most traditional, Ibels. Eight programs* by this last were used, as opposed to only two known programs by Vuillard (*Monsieur Butte* by Maurice Biollay, 1891; *Le Cuivre* by Adam and Picard,

1895). In truth, the Symbolism Vuillard was practicing at the time was better suited to other directors he was soon to encounter. Nevertheless, it was through Antoine that Vuillard was able to take his first steps in the world of the theater*, a domain in which he was to make a reputation for himself. In 1897, by which time Vuillard had collaborated with Lugné-Poe and Paul Fort* on many projects, Antoine quit the amateur stage, first establishing the Théâtre-Antoine and then working at the Odéon in 1906.

■ **Bernard, Émile**
See Pont-Aven, School of

■ **Bernheim-Jeune**
When he entered the gallery of Bernheim-Jeune in about 1900, Vuillard began a new chapter in his artistic life, both on the stylistic and professional fronts. Founded in the

Pierrot, c. 1891. Design for the program of the Théâtre-Libre. Brush and ink with watercolor highlights. 10 ½ x 8 ¼ in. (26.3 x 20.8 cm). Private collection.

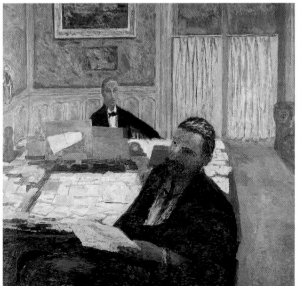

Pierre Bonnard, *The Bernheim-Jeune Brothers (Les frères Bernheim-Jeune)*, 1920. Oil on canvas, 5 ft. 5 ¼ in. x 5 ft. 1 ¼ in. (1.655 x 1.555 m). Musée d'Orsay, Paris.

Pierre Bonnard, *Portrait of Vuillard*, 1892. Oil on panel, 5 ¾ x 8 ½ in. (14.5 x 21.8 cm). Private collection, Fontainebleau.

eighteenth century, the gallery survived the centuries thanks to the efforts of successive generations of the art-dealing Bernheim family. Initially set up on rue Lafitte in 1863 by Alexandre (1839–1815)—who worked with his sons Josse and Gaston and his nephew Jos Hessel—it moved to rue Richepanse in 1900, and then on to 25 boulevard de la Madeleine in 1906. Taken up by the next generation and rechristened Bernheim-Jeune, the gallery was to become one of the largest in the Paris marketplace.

With the aim of promoting modern artists, it focused on Impressionism* and its descendants and on the avant-garde generally. The Nabis* made their appearance in the gallery through Gabrielle Bernheim (sister of Josse and Gaston, and Vallotton's* wife), taking part in a group exhibition in 1900. Soon after, Vuillard and Bonnard*, as well as Signac and Matisse, emerged as the gallery's favorite artists, exhibiting there regularly until 1913, particularly in individual shows. Through the contracts they signed with the gallery, these artists attained a measure of financial security. This new-found prosperity and recognition of his talents allowed Vuillard to enjoy a high-society lifestyle, which his links with the dealer Hessel* and his wife further fostered. At the same time, his exposure to the art at Bernheim-Jeune influenced the evolution of his style in an Impressionist direction. Following the arrival of Fénéon as artistic consultant in 1906, there were increasing numbers of exhibitions devoted to Impressionist masters. The impact of these works was to turn Vuillard increasingly back to reality and to the depiction of feeling, and—as a memorandum in his journal for 1907 testifies—he even began to question his artistic credo: "Hanging still lifes at Bernheim's this evening. Disgust with my painting. Good pieces by Bonnard. Superb coloring in the Cézannes. Classic Renoirs, brilliant Monets. I haven't had a lesson as tough as this for a long time."

■ BONNARD, PIERRE

The Japonard *friend*
Bonnard (1867–1947) enrolled at the Académie* Julian
from 1887 to 1889, and then in 1889 at the Beaux-Arts,
where through Denis* he met Vuillard, with whom he
forged a lifelong friendship. Initially influenced by Corot,
Bonnard later succumbed to the spell of Gauguin*. Within
the clan, he was dubbed the *"Nabi Japonard"* (see Nabis)
because of his fascination for Japanese art. In the same way
that Sérusier* and Denis can be said to have been allies,
Bonnard shared a special affinity with Vuillard, their art
betraying the same decorative and *intimiste* aims (see
Intimisme), rethought in the context of this Japanese influ-
ence. Until the end of the century, as Thadée Natanson* put
it, "they were practically the only ones to find no similarities
between their pictures!" As early as 1891, the painters shared
a studio on rue Pigalle and painted works that were simulta-
neously Synthetist and Pointillist. In addition to their affin-
ity on a pictorial and personal level, which is enshrined in
their portraits (*Portrait of Bonnard*, 1891, by Vuillard; and
Portrait of Vuillard, 1892, by Bonnard), the painters were
also both active in the theater* and the decorative arts*.
Associated with the madcap first night of Alfred Jarry's *Ubu
Roi* (1896) at the Théâtre de l'Oeuvre, Bonnard also turned
out lithographs (*La Revue blanche*, 1894), posters (*France
Champagne*, 1891), and book illustrations (*Parallèlement*,
1900; *Daphnis et Chloé*, 1902). He made programs* and sets
(see Sets and Scenery) for numerous plays, as well as execut-
ing designs for fans, folding
screens, and furniture.

*Portrait of
Bonnard,*1891.
Oil on
cardboard.
Private
collection.

Introduced to the Bernheim-
Jeune* gallery in 1900, the two
friends experienced what Bon-
nard called a "feeling of release"
in Impressionism*. Although
Bonnard distanced himself from
his friend and passed through a
hermetic phase in 1914–1922
(*The Café*, 1914), this artistic
divergence never threatened the
heartfelt friendship they felt for
one another. Grief-stricken by
the death of Vuillard in 1940,
Bonnard wrote to their mutual
friend Roussel*: "Far away as I
am, at odd moments I believe
that it is not true and that I will
soon once more lay eyes on that
smile beneath his hoary beard..."
(Terrasse, *Bonnard et Vuillard.
Correspondance*).

■ **Commissions**. See Anabaptists, The; League of Nations; Palais de Chaillot; Society Portraiture; Théâtre des Champs-Élysées.

■ **Condorcet, Lycée**

After schooling with the Marist Brothers, Vuillard, in a decision that was to color his choice of future career, enrolled at the Lycée Condorcet, a high school that was (with Louis-Le-Grand and Saint-Louis) one of the most prestigious in all of Paris. Born to parents from a business and military background, the artist could have followed the same path, like his elder brother and sister: Marie joined the corset firm of her mother, whose father and uncle were in the textile trade, while Alexandre passed through the Polytechnique school and then joined the military like his father, a former captain of the marine army. This was also the path laid out for Vuillard upon entering Condorcet on a scholarship intended to groom him for the Saint-Cyr military school. He seems to have worked hard to achieve this aim, since from 1881 to 1884 Vuillard's name appears on the list of prize-winners. Unlike the austere spirit of the Marists, the secular, progressive education Vuillard received at Condorcet was undoubtedly favorable in developing his artistic leanings. Located in the literary and artistic district near the Opéra Garnier, the Lycée was attended by children of wealthy families who "were used to supplementing their curricular education with visits to the theater and galleries" (Chassé). The school is also remembered for having paved the way for the glittering careers of a number of France's sharpest intellects—Marcel Proust*, for example. Vuillard was a classmate of Roussel's* in 1883 and of the playwright Pierre Veber, before meeting Denis* and Lugné-Poe*, also students at the school. Although "unforthcoming as to his plans for the future" (Veber), the Lycée's pedagogic approach, the proximity of theaters, department stores (Le Printemps), and galleries (Vollard,

Facing page:
The Chestnut Trees (Les Marronniers), 1895.
Design for a stained-glass window.
Distemper on paper mounted on canvas,
3 ft. 7 ¼ in. x 2 ft. 3 ½ in.
(110 x 70 cm).
Josefowitz collection, Lausanne.

Right:
Jean Béraud, *Leaving the Lycée Condorcet (Sortie du Lycée Condorcet)*, 1908.
Oil on canvas,
20 x 25 ½ in.
(51 x 65 cm).
Musée Carnavalet, Paris.

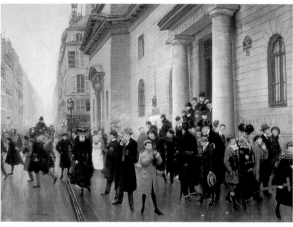

Bernheim*, Durand-Ruel), as well as the bonds he continued to forge until 1885, undoubtedly dampened his enthusiasm for joining the army. Now, together with his new comrades, he was about to enter the most rewarding period of his life, both in terms of friendship and artistic development (see *Revue blanche*, Nabis, Theater).

■ Decorative Arts

Embracing the Nabis* spirit that was determined to integrate art into everyday life, Vuillard created many pieces that can be classified as applied art. Indifferent to the creation of fans—an object typical of the Japanese culture of which he was an avid

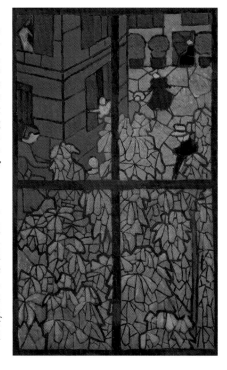

My dear Friend, Here is a proposition which comes from Ibels. He has made the acquaintance of Bing, the merchant of curios who would like to present, in France, with the help of artist-decorators, a special type of colored glass where one can achieve all kinds of color, including graduations in the same color while the glass remains transparent. He has, at his home, samples of this type of glass and samples by artists of the country (who are Americans). Ibels has told him about all of us and Bing is waiting to show us samples. He would take it upon himself to have our sketches executed because the fabrication itself is a secret which they will not divulge. Would you like to come to see it? It might interest you. All of us have made an appointment at about 3 p.m. in my studio. Come, since it should interest you and Bonnard most of all.

Letter from Vuillard to Denis, May 30, 1894.
Quoted in Weisberg, *Art Nouveau Bing*, Paris Style 1900.

collector—he nevertheless produced three folding screens, an equally Japanese artifact, more familiar to him since he possessed one himself. The first, representing seamstresses in a workshop, forms part of the interior decor designed for Paul Desmarais's mansion. Dating from 1892, it was inspired by Japanese art (see Japonism) and remains close in spirit to screens by other Nabis. It nevertheless differs from pieces by Sérusier* and Denis* in being painted not in oil but with *peinture à la colle*—pigment mixed with hot glue—a technique Bonnard* also adopted in 1894. The screen's design recalls the ornamental panels in the room, which remained very much in the Art Nouveau tradition (Émile Gallé). The second screen was carried out in 1895 at the request of Stéphane Natanson* and originally comprised four panels. Profoundly Japoniste in spirit—in terms of the representation of the space and the figures—it depicts Misia* and Stéphane *en tête-à-tête*. In 1911, Vuillard made one last screen for Princess Bassiano, though this time the motif, inspired by the Vintimille public garden in Paris, is a more realistic one.

Stained glass, motivation for much of the Cloisonnism and Synthetism of the Pont-Aven masters, naturally attracted the attention of the "prophets." Responding to a request from Siegfried Bing, direc-

tor of La Maison de l'Art Nouveau in Paris and a fervent promoter of decorative art, Vuillard designed one project for stained glass (*Chestnut Trees* [*Les Marronniers*], c. 1894), a single element in a series on which Roussel*, Bonnard, Ibels, Denis, Sérusier, Vallotton*, and Toulouse-Lautrec were all to collaborate. Completed by master glassmaker Tiffany, these projects were exhibited in April 1895 at the Salon of the Société Nationale des Beaux-Arts. Vuillard's effort was particularly successful and was presented in Bing's gallery in December 1895 among six others by fellow-exhibitioners. As was Gauguin* before him, Vuillard, like Bonnard and Denis, was interested in ceramics. In 1895, he made a series of earthenware plates for the writer Claude Anet, which were exhibited at Bing's the same year.

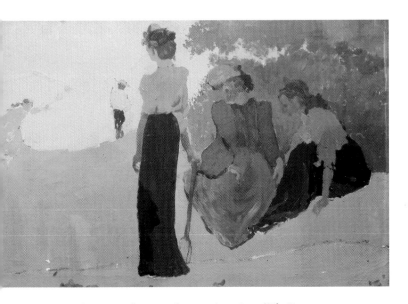

■ Decorative Panels

In parallel with his activities as a painter, Vuillard was responsible for many ornamental panels that decorated the apartments, private mansions, and villas of his patrons. Although this type of painting—by introducing art into everyday life—partook of the Nabis* spirit, the painter continued to devote himself to decorative art* right up to 1922. Vuillard produced his first ensemble in 1892 for the office and bathroom of Paul Desmarais's mansion located on rue Malakoff (today, rue Raymond-Poincaré). Composed of four outside scenes (*Nursemaids and Children in a Garden, Petting the Dog, Gardening, The Game of Badminton* [*Nourrices et enfants dans un jardin public, La Caresse au chien, Le Jardinage, La Partie de volant*]), its sparse language contrasts with the cluttered world of the two interiors (*The Dressmaking Studio I* and *II* [*Un Atelier de couture I* and *II*]). Executed in the Japonist spirit (see Japonism), some of the broad, mellow tones in these scenes hark back to Puvis de Chavannes*, in the same fashion as Vuillard's celebrated series, *Public Gardens* (*Jardins publics*, 1894). In 1895 he painted five panels for the apartment of Thadée Natanson* on rue Florentin (*The Album, The Stoneware Pot, The Washstand, The Tapestry, The Striped Blouse* [*L'Album, Le Pot de grès, La Table de toilette, La Tapisserie, Le Corsage rayé*]). Chromatically unified, the panels depict women occupied in various middle-class pursuits (reading, flower arranging) in cozy interiors, all in a quintessentially Nabis spirit. Setting up an engaging dialogue between woman and room by means of the flowers

Decorative panel for Paul Desmarais, 1892. *The Game of Badminton (Une partie de volant).* Oil on canvas, 1 ft. 7 in. x 3 ft. 10 in. (48.5 x 117 cm). Private collection, Paris.

running over both the dresses and the wallpaper, the panels are inspired by Misia Natanson's* private world, but also by the *millefleur* tapestries the painter admired at the Musée de Cluny. The same spirit informs the pieces composed for Adam Natanson in 1899 (*Window Giving on to the Woods* [*Fenêtre donnant sur les bois*], *First Fruits* [*Les Premiers fruits*]). Described by Denis* as "sumptuous hangings [similar to] old tapestries," they took as their starting point a journey made to L'Étang-la-Ville, and heralded the painter's development towards larger formats. The painter's Impressionist (see Impressionism) turn—already noticeable in the three panels of *The Garden at Villeneuve-sur-Yonne* painted for the writer Claude Anet (*In Front of the House* [*Devant la maison*], 1898; *In the Garden* [*Dans le jardin*], 1898; *The End of Lunch in the Garden* [*La Fin d'un déjeuner au jardin*], 1901)—resurfaced in The Haystack (*La Meule*) and *The Tree-Lined Avenue* (*L'Allée en*

sous-bois, 1907–1908) for Princes Emmanuel and Antoine Bibesco, and in the ensemble conceived for the Villa Bois-Lurettes belonging to Bernheim-Jeune* at Villers-sur-Mer (1912). This last, which comprises seven large elements, contains in particular a sublime doorframe that features, on one side, Lucie Hessel and Denise Natanson bathed in a soft light, and, on the other, Misia Natanson and Marthe Mellot (*The Veranda of Coadigou at Loctudy* [*La Véranda du Coadigou à Loctudy*]). As for the series *At the Louvre* (*Au Louvre*), painted between 1921 and 1922 for Camille Bauer from Basel, Vuillard opted for a more traditional treatment for this homage to the heritage of France. Having displayed his gifts as an interior decorator, in 1913 the artist went on to satisfy a penchant for monumental compositions in public buildings at the Théâtre des Champs-Élysées*, the Palais de Chaillot*, and the League of Nations* in Geneva.

Decorative panel for Paul Desmarais, 1892.
The Dressmaking Studio I
(Un atelier de couture I), detail.
Oil on canvas,
1 ft. 7 in. x 3 ft. 10 in.
(48.5 x 117 cm).
Private collection, Paris.

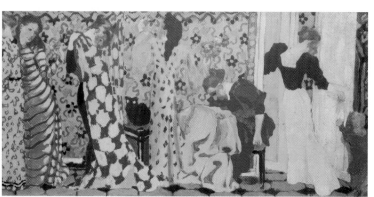

■ Denis, Maurice

From theory to empiricism

A major thinker and artist, Maurice Denis played a crucial role in rallying Vuillard to the Nabis* cause. Born in Granville in 1870, Denis met Vuillard at the Lycée Condorcet* before entering the Beaux-Arts and the Académie* Julian in 1888, where he became acquainted with Sérusier*. Immediately converted by the latter's *Talisman**, he adopted its aesthetics (*Sunlight on the Terrace* [*Taches de soleil sur la terrasse*], 1890), taking on the role of the Nabis' theorist, and publishing its manifesto in *Art et critique* in 1890. His brilliant

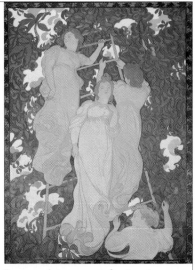

account of "Neo-Traditionalism" exerted immense fascination on Vuillard (see *Au lit* [*In Bed*]), then still a Naturalist. Literally bewitched, Vuillard soon moved away from his intuitive and empirical attitude to take up a form of art governed by the methodology of Denis and Sérusier: "A firmly established theory can relax the mind and help me develop further. Obviously Sérusier is right to say one should not worry about the subjective expressiveness of an artwork; that's the viewer's business" (*Journal**, 1890). To the delight of his friend Bonnard*, with whom he now shared a studio on rue Pigalle (1891), Vuillard thus adhered to the "prophets'" cause, though not without misgivings. Fortified by Bonnard, however, he slowly gave up struggling against his true inclinations, attaining a compromise in a decorative style distinct from the mystical path taken by Denis and Sérusier.

Denis, closer to the artistic style of Sérusier, taught himself graphic and decorative art*, as well as set painting (see Sets and Scenery). With his religious approach, Symbolist leanings, and fascination with women (*The Orchard of the Virgins* [*Le Verger des vierges*], 1893; *The Ladder in the Foliage* [*L'Échelle dans le feuillage*], 1892), he was soon dubbed the "Nabi of the beautiful icons." In a letter dated 1897, in which he tried to convince Vuillard to adopt a style of art governed by the "will," Denis conceded that he no longer exerted the sway he once did over his fellow artist. Vuillard confessed to a desire to create an art informed instead by a "savor," by an "assent" (Vuillard to Denis, 1897). After 1900 the two artists embraced very different approaches—Impressionist for Vuillard, Neoclassicist for Denis—though they were to continue collaborating creatively on sets and scenery for the Théâtre des Champs-Élysées* (1913), decorations in the League of Nations* in Geneva (1938), and even in Vuillard's portraits of *The Anabaptists** (*Les Anabaptistes*, 1923–1937).

Maurice Denis, *The Ladder in the Foliage (L'Échelle dans le feuillage)*, 1892. Oil on canvas, 7 ft. 4 ½ in. x 5 ft. 6 ½ in. (2.25 x 1.69 m). Musée Départemental du Prieuré, Saint Germain-en-Laye.

■ **Exhibitions**

Not particularly enamoured of junkets of this kind, the artist agreed to exhibit regularly only from 1891 to 1913, and later for retrospectives at the end of his career. As a little-known Nabi*, from 1891 he participated in joint shows by the "prophets," whereas his first individual exhibition was staged under the auspices of the *Revue blanche** group in 1892. He collaborated from 1891 to 1894 in shows in the Barc de Boutteville gallery that drew press comment, and in 1894 at Saint-Germain-en-Laye. He also participated under the group's wing at the Libre Esthétique in Brussels in 1896, 1901, and 1905, and in the various Secessions organized in Berlin, Munich, and Dresden from 1901 to 1911. He showed at the "Homage to Redon" organized in 1899 at Durand-Ruel's gallery, and, in about 1897, in a hanging of prints executed in collaboration with Denis* and Bonnard* at the gallery of Vollard. Acknowledged as a Nabi, after the turn of the century he was to attract considerable critical interest. Contracted to Bernheim-Jeune's*, he won over the public in a long line of one-man and collective shows on its premises from 1900 to 1913, but more especially by his contributions to the Salon des Indépendants (1901–1906, 1909, 1910) and the Salon d'Automne (1903–1906, 1910, 1912). His work now in vogue, plaudits came thick and fast, often contrasting it with the excesses of the Fauves and Cubists who exhibited at the Salon des Indépendants in 1905 and 1911. As such, he attracted a substantial following hostile to contemporary currents, and, greatly admired in the elevated social circles in which he moved in Paris, he was soon seen as high society's* official portraitist (see Society Portraiture). As he received a large number of commissions and belonged to no artistic or art-dealing circle, Vuillard felt little urgency to exhibit regularly after 1914. Devoting himself to his art, he showed only sporadically until 1935; however, he did participate in the retrospective of *La Revue blanche* painters in 1936 and in a one-man exhibition at Bernheim-Jeune in 1938. Following protracted negotiations, he allowed the organization of the 1938 retrospective in the Pavillon Marsan in the Louvre*, the most thorough showing of his oeuvre prior to his death, and that which unveiled his late portraits. A comprehensive understanding of his work has only been possible at posthumous exhibitions, in particular the Roussel* donation show at the Musée de l'Orangerie (1941–1942), in which some of his finest pieces emerged (*In Bed** [*Au lit*], 1891).

■ **Fort, Paul**

Born at Reims, the poet Paul Fort (1872–1960) attended the Lycée Louis-le-Grand in Paris. While no more than a teenager, he set up the Théâtre d'Art (1890). In opposition to the Naturalist staging of Antoine, Fort believed that dramatic art should relate to dreams and

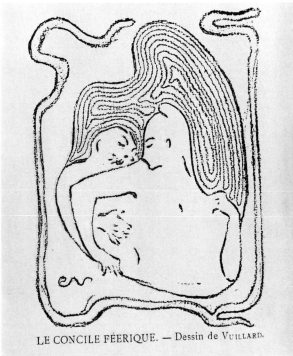

LE CONCILE FÉERIQUE. — Dessin de VUILLARD.

3. THÉODAT ∴

en prose, de REMY DE GOURMONT : décor

Program for
*Le Concile
Féerique*, 1891.
Reproduced in
Théâtre d'Art.
Private collection.

promoted Symbolist (see Symbolism) theater*. It was an approach the Nabis* could identify with, and Fort provided them with opportunities to prove themselves in the theatrical field. With scant resources, Gauguin*, Bernard, Redon, Denis*, Ibels, Sérusier*, Bonnard*, Roussel*, and Vuillard produced Synthetist set designs (see Sets and Scenery) for plays by Verlaine and Shelley and the Symbolist-leaning Remy de Gourmont, Jean Laforgue, and Rachilde. They were also often responsible for the theater's programs* and sometimes for costumes in a Symbolist spirit. To reinforce the dreamlike magic of the illusion, the director called upon his players—stars such as Lugné-Poe* and Suzanne Desprez—to act in a solemn style, lighting the set nonnaturalistically. Fort was of the opinion that "the word creates the set just as it does everything else." His guiding principle of artistic synthesis was manifest in his adaptation of the *Song of Songs* (*Cantique des cantiques*) by Paul Napoleon Roinard, in which the stage was lit with various colors, and scent and music wafted through the auditorium. The public reacted strongly to such innovative liberties. To publicize his Théâtre d'Art, Fort set up a poetry review of the same name that published illustrations and programs designed

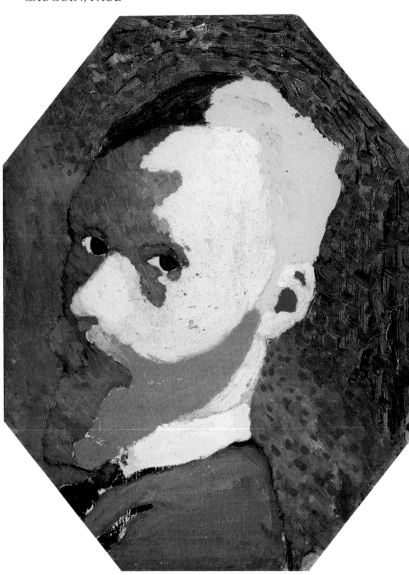

Edouard Vuillard, *Octagonal Self-Portrait (Autoportrait octogonal)*, c. 1890. Oil on cardboard, 14 ¼ x 11 in. (36 x 28 cm). Private collection, Paris.

by artists, Vuillard among them. A true art lover, from 1891 Fort even began concluding his plays by unveiling a painting, joining forces with the Nabis in what was a genuine creative collaboration. After 1892, following the first performance of Villiers de L'Isle-Adam's Axël, he devoted himself to writing poetry.

■ **Gauguin, Paul**

Master of the Pont-Aven* School and forefather of the Nabis*, Gauguin (1843–1903) also monopolized the attention of Vuillard for a time in 1890–1891. The discovery of his teaching through Sérusier's* *Talisman** (1888) rallied Vuillard to the Nabis cause around 1889. Though rejected by the

World Fair of that year, Gauguin was able—thanks to the initiative of Émile Schuffenecker—to exhibit with his friends in a show entitled "The Impressionist and Synthetist Group" at the Café-Volpini within the Champ-de-Mars enclosure of the fair. Vuillard's encounter with Gauguin's work was to have the delayed effect of a time bomb. Perceiving in his Synthetist manner a means of escaping from conventional painting, in 1890 Vuillard began applying the ideas that the Nabis called the aesthetics of the future (Denis*), without, however, adopting the spiritual dimension of Gauguin's vision. In keeping with principles of the master—who, like Goethe, held that the greatness of an artist is to be gauged from the limits he imposes on his materials—Vuillard reduced his palette to the minimum, arranging the image in cloisonné flat tints (*Portrait of Ker-Xavier Roussel/The Reader* [*Portrait de Ker-Xavier Roussel/Le Liseur*], 1890–1891) with a sometimes arabesque-based rhythm (*Profile of a Woman in a Green Hat* [*Femme de profil au chapeau vert*], 1890–1891). In the *Octagonal Self-Portrait* (1891) and *The Lilacs* (*Les Lilas*, c. 1890), the artist strictly conformed to the principles of pictorial Synthetism, applying pure tones and shunning anecdote. Modernist canvases such as these raised questions that the Fauves and abstract artists later strove to address. *Scene in a Garden/Third Class* (*La Scène dans un jardin/La Troisième classe*, 1891), a semi-abstract

work, also partakes of the artist's Gauguinesque phase, although its various shades of brown already demonstrate a desire to temper his palette. Although during this time Vuillard composed works that foretold of revolutions to come in modern art, the phase was short-lived. Too sensitive to be limited by theory, too fond of the harmonious tones that would contribute so much to the grandeur of his later oeuvre, the artist felt unable to follow in the footsteps of Gauguin, going so far as to call him, in private at least, a "pedant."

■ Hessel, Jos
Art dealer and collector

From the turn of the twentieth century, Jos Hessel was to play a decisive role in Vuillard's existence. Starting out in Belgium as a journalist, Hessel abandoned that career upon marrying Lucie Reitz (see Hessel, Lucie), thenceforth devoting himself to the art trade. Once settled in Paris, he came across works by Vuillard in *La Revue blanche** and was soon an avid collector. Employed at Bernheim's before becoming joint director of Bernheim-Jeune*, Hessel befriended Vuillard, and the gallery was soon offering financial security to the painter. Spending a considerable amount of time in the couple's company, Vuillard now enjoyed a lifestyle distinctly superior to anything he had before experienced. Jos, a flighty individual to whom Lucie was nevertheless extremely attached, undoubtedly saw the arrival of Vuillard as a palliative to his wife's loneliness.

Moving in wealthy art-loving circles, Hessel introduced Vuillard to many aristocrats whose commissions were to steer his art in a more traditional direction (see Society Portraiture). Thanks to Hessel, however, Vuillard also met Tristan Bernard, Henry Bernstein, and Sacha Guitry, authors of comedies and farces through whom he renewed his contacts with the stage (*L'Illusionniste* series, 1922), and found patrons whose sensibility was more in tune with his own.

At least as much a speculator as an art enthusiast, Jos Hessel bet on the right horse with Vuillard, whose fame continued to grow. The painter probably saw through all this, but he was amused by the bustling world in which he was now caught up and which ensured him a comfortable income. He would certainly have distanced himself from the wider milieu, however, were it not for the comforting presence of Lucie. Since the couple forced him to get out and about more, they liberated him from the constant fear of his inspiration drying up. During these excursions with the Hessels, he would also encounter new subjects to whet his creative appetite. Staying with the couple near La Baule, he started work on marine landscapes in a strikingly modern style (*Walk in the Port*,* [*Promenade dans le port*], 1908). He was also inspired by the park at the Château de Clayes near Versailles which resembled a fairytale domain: indeed, it was in this park that Vuillard was to imagine the allegorical scene for *La Comédie* in the Palais de Chaillot* (1937).

Hessel, Lucie

It was during a stay with Vallotton* at the Château de Romanel in the canton of Vaud, Switzerland, that Vuillard became acquainted with Lucie Hessel. Daughter of a wealthy clothier, Lucie, née Reitz, married Jos Hessel*, Vuillard's future art dealer. Becoming the artist's close friend and new muse, she would furnish him with novel subjects for his art and introduce him to a whirl of social engagements. A benevolent spirit with a strong personality, she invited Vuillard on countless occasions to stay in her apartment on rue de Rivoli, then on rue de Naples where he met much of Parisian society*. Among these acquaintances, Vuillard was to encounter affluent art lovers to whom he was to devote much of his career between 1915 and 1940. In time off between two formal portraits, Vuillard found an inexhaustible fund of inspiration in Lucie, whom he photographed (*Madame Hessel before her Portrait*) and painted with unequalled freedom. Though as a rule seeking to stress the elegant assurance of his muse (*Lucie Hessel before the Sea* [*Lucie Hessel devant la mer*], c. 1904; *Woman in a Hat, Amfreville* [*Femme avec un chapeau Amfreville*], c. 1905), Vuillard also regularly showed her in more suggestive poses (*Madame Hessel Lying on a Couch* [*Madame Hessel étendue sur le divan*], c. 1920; *The Siesta/Madame Hessel Reclining* [*La Sieste/Madame*

Madame Hessel with her Dogs (Madame Hessel et ses chiens), c. 1935.
Pastel on paper, 25 ½ x 19 ¾ in. (65 x 50 cm). Private collection.

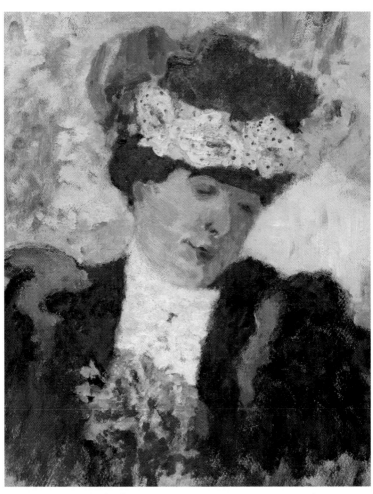

Madame Hessel Wearing a Hat with Roses (Madame Hessel au chapeau garni de roses), c. 1905. Oil on paper mounted on canvas, 21 ½ x 13 in. (54.5 x 33 cm). Originally 23 ½ x 19 ¾ in. (60 x 50 cm). Private collection.

Hessel allongée], 1918) or in some private moment (*Lucie Hessel's Bedroom/The Manicure* [*La Chambre à coucher de Lucie Hessel/La Manucure*] c. 1907). Become, as the manservant Eugène put it, "painter to the house," Vuillard accompanied Lucie and her husband on peregrinations to Criqueboeuf, Trouville, and Cabourg in Normandy, and to Saint-Jacut, Pouliguen, and Loctudy in Brittany. He returned with sketches and photographs that back home he hastened to work up into paintings. A regular visitor to their houses at Vaucresson between 1917 and 1924 (*In the Garden of the Clos Cézanne* [*Dans le jardin du Clos Cézanne*], 1923–1933) and Versailles from 1926 on (*The Château de Clayes,* c. 1931), there too he exploited a rich vein of themes. A faithful friend (and perhaps more; see Journal*), Lucie proved particularly solicitous to the artist on the death of his mother in 1928, and likewise at the time leading up to his own demise in 1940.

◾ IMPRESSIONISM

Alive with a feeling of fresh air and idleness conveyed by a luminous, varied palette applied with a brush alternately fluid and taut, the works Vuillard produced between 1900 and 1910 testify to his adherence to the Impressionist style. As early as 1894 (in the *Public Gardens** [*Jardins publics*] series), Vuillard made references to Monet, whom he had probably encountered at Durand-Ruel's, George Petit's, and Goupil's. His interest strengthened from 1898, the year in which he produced many indoor scenes inspired by homely pursuits (*The Garden at Villeneuve-sur-Yonne* [*Le Jardin à Villeneuve-sur-Yonne*], 1898). His association with Bernheim-Jeune* in 1900, however, led him to fully absorb the lessons of the movement.

Through intense study, he moved away from the confined, introspective, and sometimes disturbing Nabis* universe (*The Artist's Grandmother* [*La Grand-mère de l'artiste*] 1891–1892) to a world at once airy and luminous, even jovial. This shift is apparent both in *The Mantelpiece* (*La Cheminée*, 1905) and *Mme Hessel and Denise Mello/The Sunny Morning* (*Madame Hessel et Denise Mello/La Matinée ensoleillée*, 1910), in which the bright sunlight is a far cry from the artificial illumination typical of earlier works, and in the darting brushstrokes of *The Haystack* (*La Meule*, 1907–1908), whose subject refers back to the series by Monet (1871). Keen to brighten his color range, he then tried his hand at landscape*, deploying Monet and Caillebotte's bird's-eye view (*Place Vintimille*, 1908; *The Game of Checkers at Amfreville* [*La Partie de dames à Amfreville*], 1906). In harbor and coastal scenes from 1908 to 1913, he combined transparency and fluidity of palette with the flatness of Gauguin (*The Beach at Saint-Jacut* [*La Plage à Saint-Jacut*], 1909). In 1910, jettisoning the Nabis' blocks of shadow, he gradually forsook Impressionism, too, in favor of a more traditional execution, though he never lost his interest in the movement's explorations and ideas. Salomon describes how overwhelmed Vuillard was when, in the company of Bonnard* in 1925, he stumbled across *The Waterlilies* at Monet's. According to Bonnard, "When we later came upon Impressionism, we were filled with newfound enthusiasm, a feeling of discovery, of liberation" ("Leurs débuts," *Les Nouvelles littéraires*, July 29, 1933).

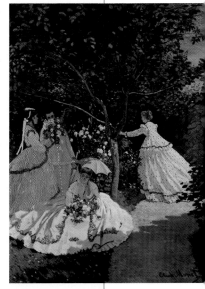

Claude Monet, *Women in the Garden*, 1867.
8 ft. 8 ½ in. x 6 ft. 8 ¾ in. (2.55 x 2.05 m).
Musée d'Orsay, Paris.

■ IN BED (AU LIT)

ong hidden away by the painter, who regarded it as little more than a "youthful exercise" (Salomon), *In Bed* now appears as not only the most daring creation of Vuillard but of the Nabis* in general. An amalgamation of references to the "prophets," it once again melds the qualities of Synthetism, Symbolism*, and Japanese art (Cogeval, *Vuillard Le Temps détourné*). Starting out from a very simple subject, a sleeper, the artist approached his work, not in terms of the subject represented, but as autonomous pictorial material. Subscribing to the lesson of Gauguin*, Vuillard partitioned each object into broad areas of flat tint rendered with a minimal range of colors. In addition, in the spirit of Puvis de Chavannes*, he used pastel tones integrated into a totally planar composition. Amplified by a supple, swirling rhythm taken from Japanese prints, the figure, ensconced among plump cushions, is captured in a state propitious for dreaming—that privileged expression of Symbolism.

Although methodically conceived, *In Bed* nevertheless exudes poetry, not only through a subject that captures a fleeting, intimate moment, but through the harmony of tone and limpid textures of its color planes. A strict application of Denis's* famous dictate—"Remember that a canvas, before it is a naked woman, a war-horse or some anecdote or other, is first of all a plane surface to which colors assembled in a certain order are applied." (*Art et critique*)—Vuillard's masterpiece, if unbeknownst to its creator, foretold both Cubism and abstraction. Once these art movements appeared, however, he fully opposed them and refused to continue down this path, evolving towards a Realism* that was further accentuated after 1900.

In Bed (Au lit), c. 1891. Oil on canvas, 28 ¾ x 36 ½ in. (73 x 92.5 cm). Musée d'Orsay, Paris.

■ INTIMISME

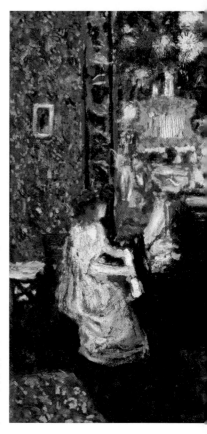

As the critic Claude Roger Marx noted: "Vuillard seems to have understood very early that his discoveries would only be made in a limited field, that he would find happiness only in a cosseted world." Indeed, in 1893 the artist remarked that he found the most inspiration in "familiar places." Deeply attached to his mother, with whom he would live until her death, for many years her petit-bourgeois world proved the determining factor in his art. Though scenes from daily life did constitute a favorite subject, the artist, who described himself as an "intimiste," skillfully avoided the humdrum and repetitive. By repeatedly modifying the atmosphere, framing, and lighting of his subjects and by changing their surroundings, the artist succeeded in the delicate task of elevating the immutability of everyday life into a source of wonder. Portraying his mother no less than five hundred times—sewing, sweeping, or cooking—he imbued each work with fresh poetry (*The Floral Patterned Dress* [*La Robe à ramages*], 1891; *Interior with Women Sewing* [*L'Aiguillé*], 1893). Under the preponderant influence of Symbolism*, Vuillard never gave up painting familiar scenes that he presented in unreal lighting and spaces (*Under the Lamp* [*Sous la lampe*], 1892). Even when tackling landscape*, he transformed it into a scene of intimacy (*The Interrogation* [*L'Interrogatoire*], 1894). Discovering in Misia Natanson* a new mother figure, he took material from the world she inhabited. From an affluent milieu, the beautiful Misia and their mutual friends undergo an evocative Nabis* treatment, as they busy themselves at their bourgeois pastimes in her Paris apartment (*Misia at the Piano with Cipa Listening* [*Misia au piano et Cipa l'écoutant*], 1897) or

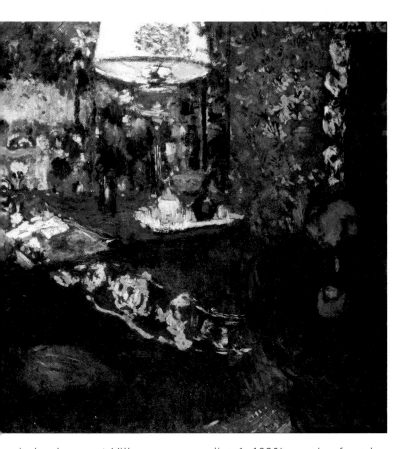

in her house at Villeneuve-sur-Yonne (*In the Garden* [*Dans le jardin*], 1898). When Misia was replaced after 1900 by Lucie Hessel*, the artist applied himself to depicting the upper echelons of society. First bathed in soft, Impressionist light (see Impressionism) beneath the veranda of a villa in Brittany (*Lucie Hessel and Denise Natanson*, 1912), she can later be seen posing for a manicure (*Lucie Hessel's Bedroom/The Manicure*, [*La Chambre à coucher de Lucie Hessel/La Manucure*], c. 1907). Vuillard's realistic handling allows her age to be guessed at, as she lounges elegantly clad in her living room on rue Naples (*Mme Hessel Lying on a Couch* [*Mme Hessel étendue sur un divan*], 1920), or else from her increasingly gray-white hair (*The Château de Clayes*, 1931). By dint of his muses (his mother, Misia, and Lucie), Vuillard left an extraordinary testimony of the way three women from three different social backgrounds played out their lives in the years between 1888 and 1940.

Misia at the Piano (Misia au piano).
Oil on cardboard, 17 ¼ x 21 ¾ in. (54 x 80 cm).
Private collection.

49

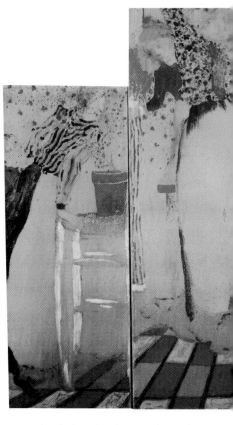

T he Nabis*, through the interest they displayed in the arts of Japan, were part of a wave of "Japonisme" that swept over France from 1850. If the preceding generation of Monet, Degas, Whistler, and Manet had channeled this tide into renewing what they considered hackneyed iconography, Vuillard, Bonnard*, Denis*, and Ranson* proposed instead a fresh view on depicting reality. Vuillard started building a collection at the exhibitions devoted to Japanese art at the Galerie Bing in 1888 and the académie des Beaux-Arts in 1890, soon acquiring Book VI of Hokusai's *Manga*, an album by Kitao Masayoshi entitled *Ryakuga Shiki*, and prints by the masters Hiroshige and Harunobu. In the light of artists such as these, between 1890 and 1893 Vuillard reconsidered the representation of space and the figure and explored new formats.

Abandoning spatial construction through perspective, after 1890 he adopted a planar style characteristic of the Japanese vision (*In Bed* [*Au lit*], 1891). He then took up another print technique, used in particular by Utagawa Kuniyoshi, to reintroduce depth: the ground surface is represented from high overhead, while the figures are portrayed frontally (*Under the Lamp* [*Sous la lampe*] 1892; the Desmarais panels, 1892). Human figures meanwhile were nullified through processes borrowed from Ukiyo-e painters, who were also

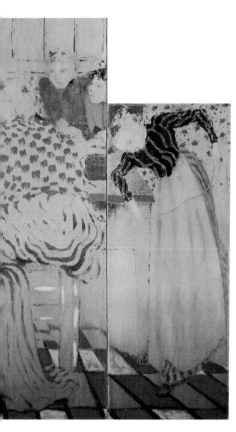

inspired by everyday life. Depicted without relief, the outline of his figures was soon to adopt the "S" curve (*Biahna Duhamel in Miss Helyett*, 1890–1892; *Marthe Mellot*, 1891) specific to Japanese female figures, in particular those of Masayoshi. Although this feature became less pronounced after 1892, Vuillard continued to show his figures as if frozen. One can also compare the manner in which he relegates his sitters to a more distant plane, highlighting instead the patterns on their clothing, to Japanese artists such as Utagawa Kuniyoshi and Ishikawa Toyonobu (*The Artist's Mother and Sister* [*Mère et soeur de l'artiste*], 1893; *Interior at the Dressmaker's/The Suitor*, [*L'Atelier à ouvrage/Le prétendant*], 1893).

Finally, when Vuillard turned to the applied arts, he naturally adopted the vertical oblong of a kakemono in his folding-screens. Vuillard's exceedingly bold Japonism not only spurred his interest in the decorative (see Decorative Arts), it also enabled him to raise pictorial questions that were later to be probed further by Cubism.

The Desmarais panels. *The Dressmakers (Les Couturières)*, 1892. Four panels, distemper on linen mounted on canvas. *The Dressmaker (La Couturière)*, 3 ft. 1 ½ in. x 1 ft. 3 in. (95 x 38 cm); *The Fitting (L'Essayage)*, 3 ft. 11 ¼ in. x 1 ft. 3 in. (120 x 38 cm); *Little Hands (Les Petites Mains)*, 3 ft. 11 ¼ in. x 1 ft. 3 in. (120 x 38 cm); *The Mislaid Reel (La Bobine perdue)*, 3 ft. 1 in. ½ x 1 ft. 3 in. (95 x 38 cm). Private collection.

■ JOURNAL

Thanks to the Roussel* gift of 1943 and to an anonymous donation in 1980, most of Vuillard's private notebooks have been reunited at the Académie des Beaux-Arts in Paris. Like the majority of painters' writings, his journals concentrate on recording his activities as an artist. Periodically left off, the diaries do nonetheless clarify certain turning points in his life and cast a revealing light on his development. This is the case for the years 1888–1894 and 1914–1915, which are rich in entries.

Notes and sketches from the first period show that it was primarily devoted to creation and to the painter's struggles to free himself from external influences. In one entry, he observed that he had been going to the Louvre* since 1888, then immersed himself in the avant-garde theaters*. In a stream of observations dating from 1890, Vuillard can be seen toiling to break away from Naturalist ideas, subscribing to the theories of Maurice Denis*, and then turning away from his and Sérusier's* potent influence in 1893, when he finally decided to devote his efforts to "familiar places," a choice he justified by quasi-ethical principles (see quotation). As a result, from 1914 reflections and sketches were steadily replaced by lists of events in his daily life. As Vuillard's existence was changing, he not only spent less time writing in his notebooks but also with his artwork. Not a day passed without him seeing Lucie Hessel* or dining with some celebrity, such Sacha Guitry or Tristan Bernard. His tastes, too, evolved in step with these new acquaintances. At the theater, he would see plays and light comedies. During a stay in Italy, he was much struck by Titian's frescos; he became interested in Second Empire painters upon visits to Versailles (Franz Xavier Wintherhalter) and the Opéra Garnier (Jules Élie Delaunay).

As for his friendships with women, the journal notes a "sentimental confidence" made to Bonnard* in 1894, a year in which he drew closer to Misia Natanson*, as well as revealing the sometimes stormy character of his relationship with Lucie Hessel. If Vuillard remains discreet as to his true feelings towards his muses, he is more forthcoming concerning his model Lucie Ralph: in 1915, he admits being "receptive to her charm." An actress under the stage-name Lucie Belin, Vuillard seems to have had a relationship lasting several years with this woman (*Lucie Belin's Smile/Young Woman with an Open Book* [*Le sourire de Lucie Belin/Jeune Femme au livre ouvert*], 1915).

> "*Faced with well-known forms and objects, the soul invents a new vision, a new idea, unconstrained by the external modifications entailed by supposedly new forms or objects whose correspondence with forms and formulas with which it is already acquainted would monopolize it and limit one's inventiveness.*"

(Vuillard, *Journal*. Transcribed by Françoise Alexandre, *Édouard Vuillard—Carnets intimes.*)

Extract from Vuillard's *Journal*, c.1890–1905. Bibliothèque de l'Institut, Paris.

■ Landscapes

Although most celebrated for his interiors, Vuillard also produced many Paris* cityscapes, as well as seaside and country views. Though landscapes had been important to him early in his artistic career, they became more numerous after 1900 when the painter returned to Realism* and started traveling more frequently. Often airier than his interiors, the majority are nevertheless still dominated by a concentration on structure (*The Boatman* [*Le Passeur*], 1897) and a decorative impulse (*The Garden* [*Le Jardin*], 1890) already perceptible in his early works. It is as if the artist was striving to create a perfect, even impenetrable image of the external world.

Paris presented Vuillard with two paramount subjects for landscape: public parks and streets. *The Streets of Paris* series (*Rues de Paris*, 1906–1908) was inspired by the Passy district and the square Vintimille—of which he also made a series of low-angle views. Shown frontally, the two decorations for place Saint-Augustin (1912–1913) are more accessible, although the division of space into two planes and the placement of the figures recalls a stage set (*Le Syphon*). Such distancing is accentuated in the country landscapes executed around 1900: tapestry, like compositions such as the decorations commissioned by Claude Anet (*Window Giving on to a Wood, First Fruits* [*Fenêtre donnant sur les bois, Les Premiers fruits*], 1899), inspired

Landscape at L'Étang-la-Ville (Paysage à L'Étang-la-Ville), 1900. Oil on paper mounted on cardboard, 20 x 19 in. (51 x 48 cm). Musée d'Orsay, Paris.

by views of L'Étang-la-Ville, and the stylized, ornamental *Landscape with Blue Hills* (*Paysage aux collines bleues*, 1900), painted in Romanel, Switzerland. Two works for Prince Bibesco, The Haystack (*La Meule*) and *The Tree-Lined Avenue* (*L'Allée en sous-bois*) appear more realistic, although here the compositions derive from elements borrowed from black-and-white photographs. To Vuillard's eternal regret, the recourse to photography resulted in "gloom [and a] lack of interest in terms of value and color" (quoted in Thomson, *Vuillard*), defects rectified in his harbor and coastal views. Thus, he fused clarity and brilliance of palette with an idealized interpretation of his vision, while other works of the time are sub-

Peace Protecting the Muses/Pax Musarum Nutrix (La Paix protectrice des Muses/Pax Musarum Nutrix), 1937–1938. Distemper on canvas, 36 ft. 1 in. x 22 ft. 11 ½ in. (11 x 7 m). United Nations, Geneva.

jected to an Impressionist (see Impressionism)—or, after 1910, Realist (see Realism)—treatment. The pictures produced in Saint-Jacut in 1909 (*The Beach at Saint-Jacut* [*La Plage à Saint-Jacut*]), in Pouliguen in 1908 (*The Walk in the Port,** [*La Promenade dans le port,*]), in Hamburg in 1913 (*Cargo-ship at the Quayside* [*Le Cargo à quai*]), and in Honfleur in 1919 (*The Port at Honfleur* [*Le Port d'Honfleur*]) partake of the same spirit.

■ League of Nations, Geneva

In 1938, one year after Vuillard had finished *La Comédie* for the Palais de Chaillot*, the French state placed a further order with him to decorate the Assembly Room of the League of Nations in Geneva. On this final major project, he was once more to collaborate with his longtime friends, Roussel* and Denis*, who were also commissioned. After the horrors of the First World War, it was not unnatural for Vuillard to choose *Peace Protecting the Muses/Pax Musarum Nutrix* (*La Paix protectrice des Muses/Pax Musarum Nutrix*), as a suitable theme to gaze down on the debates held by the organization, which was founded in 1920 to ensure the cooperation of signatory states of the Treaty of Versailles, and thereby guarantee peace and security for all nations. For this piece of his twilight years, the artist once again eschewed facility. Perhaps

as an escape from the horrendous events of the 1914–1918 conflict, he resorted to allegory for the second time in his career, looking back to Puvis de Chavannes* and Le Sueur, as well as to Roussel. The physical difficulties he encountered were similar to those met with on the earlier panel for the Palais de Chaillot (he still did not have a studio), though now exacerbated by his age and the distance separating Paris from Geneva. This time the references are to a theme from Greek mythology representing the Muses at their various occupations, which he hoped might furnish the countries concerned with suitable models. The tutelary presence of Euterpe (poetry and music), Clio (history), and Thalia (comedy)—who, as Homer said, "have only a single thought, their hearts aspiring only to song and their spirit released from every care"—is accompanied by nymphs gamboling in a dark forest beneath a sheltering sky.

■ Louvre

Although he attended courses at several art schools—the Gobelins, the Académie* Julian, and the

Decoration for Camille Bauer, *The Salle des Caryatides in the Louvre (La Salle des Caryatides au Louvre)*, 1921. Distemper on canvas, 5 ft. 5 ¾ in. x 4 ft. ¼ in. (1.67 x 1.38 m). Private collection, Switzerland.

Decoration for Camille Bauer, *The Salle Lacaze in the Louvre (La Salle Lacaze au Louvre)*, 1921. Distemper on canvas, 5 ft. 3 in. x 4 ft. 3 ¼ in. (1 m 6 cm x 1 m 30 cm). Private collection, Switzerland.

Beaux-Arts—Vuillard seems to have learned more from his daily visits to the Louvre that began in 1888. In this museum that houses one of the greatest public collections in the world, as well as absorbing the techniques he sought, he honed his artistic sensibility. As is evident from the annotations and sketches in his journal, he paid special attention to Holbein, to sixteenth-century Venetian masters (Veronese and Titian), to Dutch seventeenth-century painting (Rembrandt and Vermeer), and to eighteenth-century French artists such as Chardin, Watteau, and Le Sueur. Salomon refers to photos of works by Rembrandt and Le Sueur hung about the artist's rooms and the "innumerable comments" made by the painter on scenes from the *Life of St. Bruno* and *Artists Gathered around a Table* by Le Sueur. If the artist was to forsake his studies temporarily at the time of his adherence to the Nabis*, thereafter he examined the Old Masters ceaselessly, as shown by the consummate series of six panels entitled *At the Louvre (Au Louvre)*, started in 1920 after the institution had reopened following its enforced wartime closure. An illustration of Vuillard's striving for personal rebirth, *At the Louvre* is also a declaration of national solidarity. Much troubled by the museum's plight, here Vuillard aligns himself with the masters whose desire for completion he now seems to make his own. In the process, he found himself opening up to a new world, turning away from his intimiste (see Intimisme) references (Chardin, Vermeer), and engaging in a spiritual communion with more sensual artists such as Renoir, Watteau, and Boucher.

Particularly receptive to the eighteenth-century French tradition featured in the *Salle Lacaze* (1921), he paid due homage to the national heritage, depicting a considerable portion of the room. This first panel is accompanied by one of the *Salle Clarac* (1922) and the *Salle des Caryatides* (1921) containing Classical antiquities, and a final piece devoted to medieval sculpture, through which copyists and distinguished-looking visitors can be seen passing. Voicing a hitherto unsuspected patriotism, this series, through the subtlety and luminosity of its palette, surely ranks as one of the painter's finest creations.

■ LUGNÉ-POE

At the Théâtre de l'Oeuvre

Man of the stage and art lover, Aurélien Lugné (1869–1940), later known as Lugné-Poe, played a notable role in ushering the Nabis* into the world of the theater*. He forged ties with the brotherhood, especially Vuillard, whom he met through Denis* at the Lycée Condorcet*, an encounter that led to close artistic cooperation. While still at college he founded a theater troupe, the Cercle des Escholiers, that advocated experimentation in stagecraft. Entering the conservatory, he initially trained as an actor and stage manager at Antoine's* Théâtre-Libre and Fort's* Théâtre d'Art, and lost no time in introducing the Nabis to Antoine. Sharing common ambitions, in 1891 Bonnard*, Denis, Vuillard, and Lugné-Poe started working out of a studio on rue Pigalle that became a melting-pot for their artistic views. After his experience with Fort, Lugné-Poe put on his first play (Maeterlinck's *Pelléas and Mélisande*) in 1893, appointing Vuillard to do the sets (see Sets and Scenery). This successful debut allowed the two friends, supported by Camille Mauclair, to develop their own theater in the Symbolist spirit (Ibsen's *Romersholm*, 1893). Vuillard then became Lugné-Poe's foremost collaborator, responsible for the official name of the company, the Théâtre de l'Oeuvre, and producing the majority of the programs* and sets for the plays it staged.

An early defender of the Nabis, Lugné-Poe did not confine himself to employing painters at the Oeuvre. He also did much to publicize their art, writing a review of their first exhibition published in *Art et critique* ("Les impressionnistes et symbolistes à l'exposition de Saint-Germain-en-Laye," 1891) and allowing them to exhibit in the foyer of the theater, thereby ensuring substantial exposure in his circle—including Coquelin Cadet, Vuillard's first collector: "The Vuillards would sit in boxes belonging to prominent members whom I was canvassing at the time" (Lugné-Poe, *La Parade, I*).

Portrait of Lugné-Poe, 1891. Oil on cardboard mounted on cardboard, 8 ¾ x 10 ½ in. (22.2 x 26.7 cm). Memorial Art Gallery of the University, Rochester. Donated by Fletcher Steele.

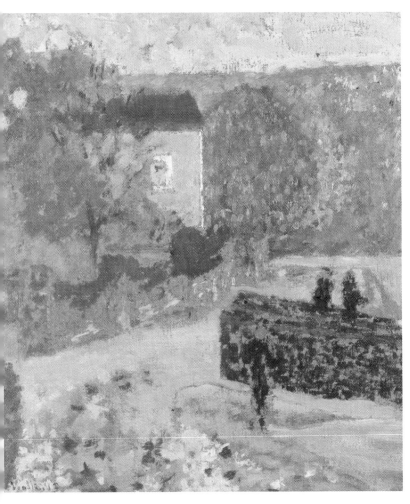

Fall at Valvins:
View of the Seine
(L'Automne à
Valvins, vue de la
Seine), 1896.
Oil on cardboard,
8 ½ x 7 ¾ in.
(21.5 x 19.5 cm).
Musée d'Orsay,
Paris.

■ Mallarmé, Stéphane

Stéphane Mallarmé, a key figure in late-nineteenth-century Symbolist poetry, made a great impression on Vuillard. Born in 1842, this onetime English teacher entered the fray against contemporary Naturalism (represented by its figurehead, Émile Zola) with writings that eschewed description in the normally accepted sense. From 1880, in his apartment on rue de Rome, he organized his famous literary "Tuesdays," which were attended by innovative poets such as Rene Ghil, Gustave Kahn, Jules Laforgue, Henri de Régnier, and Paul Valéry; important writers such as Maurice Barrès, Paul Claudel, and André Gide; and the publisher Raymond Schwab. Introduced by Thadée Natanson*, Vuillard started attending in 1894. Based on the tenet "paint not the thing but the effect it produces" and on the principle of

"Je n'ai jamais procédé que par allusions."
(I have only ever proceeded by allusion.)
—Mallarmé
(Salomon, *Vuillard.* Translation by Roger Fry.)

suggestion, Mallarmé's literary aesthetics is echoed in works Vuillard was busy producing in his nearby studio (*Mystery Interior/The Paraffin Lamp* [*Intérieur mystère/La lampe à pétrole*], c. 1893). Receptive to the poet's art, Salomon records that, during a discussion on drawing and color, Vuillard quoted verses from "The Afternoon of a Faun" ("L'Après-midi d'un faune"):

Mon crime, c'est d'avoir, gai de vaincre ces peurs / Traîtresses, divisé la touffe échevelée / De baisers que les dieux gardaient si bien mêlée...

(My crime is that, / Gay at conquering the treacherous Fears, / The dishevelled tangle divided / Of kisses, the gods kept so well commingled...)

(Salomon, *Vuillard*. Translation by Roger Fry)

Finding the increasingly hermetic style of the poet overly obscure, Vuillard stopped going to the rue de Rome Tuesdays, but he remained fond of the man. He often visited him, painting his house near the Natanson's villa in Valvins (*Fall at Valvins: View of the Seine* [*L'Automne à Valvins, vue de la Seine*], 1896), and making thumbnail sketches of the poet on a copy of *Divagations* that Mallarmé had inscribed to him. This admiration was reciprocated by the poet, who was delighted by a project hatched by Vollard for the painter to illustrate Mallarmé's *Hérodiade*. It never came to pass, however, owing to the untimely death of the "Prince of Poets" following a bout of laryngitis in 1898.

■ **Monet**. See Impressionnism

■ Mother (Madame Vuillard)

His First Muse

All those close to Vuillard are at one in acclaiming his mother's exemplary attitude with respect to her son. "She busies herself with his existence. If she had not been so wise, or if she had lacked respect for the profession in which her son was so successful, I firmly believe he would have sacrificed it for her. I will never forget the tone in which she would say: 'Aren't I his mother?'" Thadée Natanson* wrote in *Peints à leur tour* (1948.) After the death of her husband in 1893, Marie Vuillard (1838–1928), a peaceable character, found herself alone with her two sons Édouard and Alexandre, soon to study in the Polytechnique and follow an army career, as well as a daughter, also Marie. The artist's father, Joseph Honoré Vuillard, had been a retired soldier turned tax collector. Since 1879, she had run a corset-making business close to the Opéra; newly widowed and with her daughter's help, she now moved the workshop to her house on rue Saint-Honore. Although living modestly, she encouraged Édouard to become a painter and assisted him in his creative work, particularly by providing regular hospitality to his friends Ranson* and Roussel*, and by printing his photographs. In return, Vuillard remained eternally grateful, living with her in each of her apartments (see Paris) and taking her on his travels with the Natansons* and the Hessels*. In acknowledgement of this mutual affection, the painter portrayed his mother

no less than five hundred times. "Ma maman, c'est ma muse," Salomon recalls him saying (*Autour de Vuillard*). Initially envisioned as a sort of Madonna—notably in *Chatting* (*La Causette*, 1892), where, clad in all black, she appears to float in midair—she later acquires more human features that highlight her good nature (*Portrait of Mme Vuillard*, c. 1905). Although "exemplary," her omnipresence in Édouard's life undoubtedly was connected to his inability to fully share his life with a woman. Nevertheless, the artist escaped these constraints, drawing inspiration from a maternal universe filled with elegant women and fabrics, engaging in a process of sublimation on which his entire creative effort depended.

As Claude Roger-Marx put it, "Vuillard had only one great love: his mother. She inspired him under chestnut, then under gray hair; he never ceased sharing her life. Even in death, she continued to advise and protect him" (*Vuillard et son temps*).

Madame Vuillard Preparing Green Beans (Madame Vuillard épluchant des haricots verts), 1898.
Pastel on paper, 11 ¾ x 10 ¾ in. (30 x 27.3 cm). Private collection.

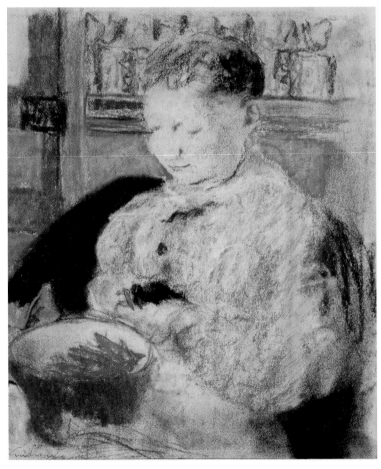

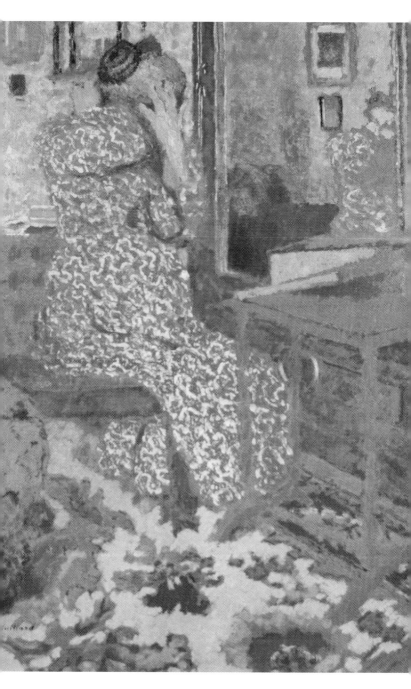

The Hairstyle (La Coiffure), 1900. Oil on canvas, 19 ½ x 14 in. (49.5 x 35.5 cm).
The Barber Institute of Fine Arts, University of Birmingham.

■ NABIS

It was while attending the Académie* Julian in 1888 that Sérusier*, Denis*, Bonnard*, Ibels, René Piot, and Ranson* formed the group of the "Nabis," so dubbed by the poet Henri Cazalis from *nebîîm*, a Hebrew word meaning "prophets." They were joined by Vuillard in 1889, then by Roussel* and Vallotton*. Enthused by the discovery of Sérusier's *Landscape in the Bois d'Amour* (*L'Aven au Bois d'amour*), the painters broke with the Academic style and set themselves the aim of creating an art for the future.

In the process, and in the light of the Synthetism and Cloisonnism of the Pont-Aven school*, the Nabis went on to bridge the gap between the crafts and easel painting. In their search for new pictorial means, they tried their hand at decorative art* (furniture, panels [see Decorative Panels], fans, folding screens, mosaic, ceramics), graphics (posters, lithographs, illustrations [see Printmaking]), and the arts of the theater* (sets [see Sets and Scenery], programs*, costumes, and marionettes). Complying with Denis's manifesto that preached the supremacy of pictorial treatment over the subject represented, they abandoned the imitation of nature—rejecting the anecdotal and resorting to arabesques, pure tones, and flatness. Furthermore, in accordance with Symbolism*, the purpose of form was solely to conjure up what was invisible. Denis, Sérusier, and Ranson represented the mystical tendency of Nabism, rather different both from the more earthbound manner of Vallotton and Roussel, and from the thoroughly decorative style of Bonnard and Vuillard.

Nicknamed the "Nabi zouave" in allusion to his red beard, between 1890 and 1892 Vuillard painted many of the most daring canvases ever produced by the movement. Devising processes of Synthetism, Vuillard's oeuvre foreshadows later Fauvist (*Self-portrait*, c. 1891) and abstract (*The Lilacs* [*Les Lilas*], 1890) discoveries. Explorations of space undertaken in the wake of Japonism* culminated in two-dimensionality (*In Bed* [*Au lit*], 1891) and in the juxtaposition of divergent angles of sight (*Under the*

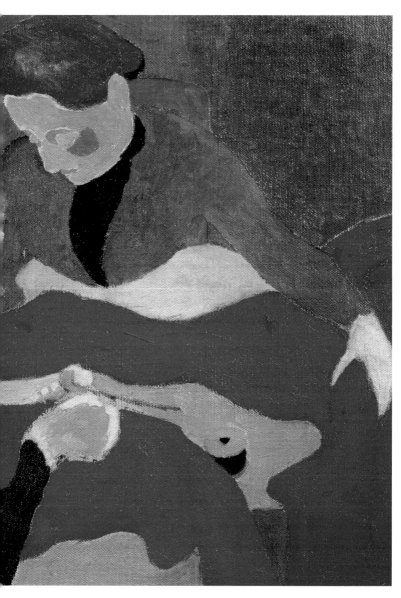

Lamp [*Sous la lampe*], 1892), heralding an idea Cubism would soon readdress. But Vuillard was dissatisfied by this theoretical approach to reality and he intuitively groped towards the central preoccupation of his oeuvre: *intimiste* scenes (see *Intimisme*). At first focusing on his mother's sewing room, then, after 1894, on interiors at Misia Natason's*, he painted the effect brought about by the texture of a dress or a carpet or by some patterned wallpaper (*Darning* [*La Ravaudeuse*], 1891; *The Washstand* [*La Table de toilette*], 1895). It was this poetic and Symbolist attitude that André Chastel was referring to when he wrote of Vuillard: "He is one of those who can hear the sound of the waves in a seashell."

The Dressmakers (Les Couturières), 1890.
Oil on canvas, 18 ¾ x 22 ½ in. (47.5 x 57.5) cm.
Josefowitz collection, Lausanne.

■ Natanson (Brothers)

Sons of Adam Natanson, a wealthy banker of Polish extraction who settled in Paris in 1880, the Natanson brothers played a dominant role in Vuillard's early career, particularly concerning commissions. Vuillard met them via a friend from the Lycée Condorcet*, Pierre Veber, in 1891, at a time when the Natansons had only recently founded *La Revue blanche**. The review was managed by the elder brother, Alexandre Natanson (1867–1936), a former banker and businessman who was later to found *Le Cri de Paris* and play a part in other journals such as *Excelsior* and *Femina*. He was in addition a collector, whose acquisitions, including masterpieces by Vuillard, were sold off in March 1929 at the Hôtel Drouot auction house. The younger brother, Alfred

Portrait of Thadée Natanson, 1906. Distemper on canvas, 6 ft. 6 ¾ in. x 6 ft. 7 in. (200 x 200.5 cm). Musée d'Orsay, Paris.

Natanson (1873–1932), staff journalist on the review, was subsequently to become theater critic of *L'Humanité* before joining the Galerie Druet. He married Marthe Mellot, an actress depicted several times by Vuillard (*The Two Sisters-in-Law* [*Les Deux belles-Sœurs*], lithograph, c. 1899; *The Game of Checkers at Amfreville* [*La Partie de dames à Amfreville*], 1906).

Lastly, there was Thadée Natanson (1868–1951), former journalist and businessman, who was the review's editor-in-chief, and who, with his wife Misia*, drew closest to Vuillard. He was also a major art collector and a sale of his pictures was organized at Drouot's in June 1908. In rue Saint-Florentin in Paris and at Villeneuve-sur-Yonne, he and Misia received avant-garde writers and artists, including many Nabis*, commissioning portraits from some of them. The afternoon pastorals at Villeneuve were immortalized in photographs by Alfred, in which Toulouse-Lautrec, Bonnard*, Vuillard, and Vallotton* can be seen passing the time. The first to admire and to stand up for Vuillard, Thadée possessed no fewer than twenty-seven pictures by the artist, and he introduced him to his cousins, the Desmarais, whose mansion the artist was to decorate. Alexandre proposed a further commission in 1893, the famous *Public Gardens* (*Jardins publics*) series. In 1895 Vuillard executed five panels for Thadée: *The Album*, *The Stoneware Pot*, *The Washstand*, *The Tapestry*, and *The Striped Blouse* (*L'Album*,

Le Pot de grès, La Table de toilette, La Tapisserie, and *Le Corsage rayé*); and finally, in 1899, the brothers' father, Adam, ordered two large ornamental panels: *Window Giving on to the Woods* and *First Fruits* (*Fenêtre donnant sur les bois* and *Les Premiers fruits*).

Natanson, Misia
Ma plus belle déclaration d'amour
Misia Natanson was the first woman with whom Vuillard had a truly close relationship. A woman venerated, even loved, by some of the foremost artists of her time, she became, after his mother*, the artist's second muse. Born in St. Petersburg, Maria Sophia Olga Zenaida Godebska (1872–1950), better known as Misia, studied under Gabriel Fauré, developing into a talented pianist. At twenty-one she married Thadée Natanson*, who at that time was editor-in-chief of *La Revue blanche**. She soon met many of the review's artists, who elevated her to the status of a tutelary genius. For Erik Satie, she was the "Magicienne," for Mallarmé*, the "Polish Princess," and she inspired Bonnard*, Toulouse-Lautrec, and Renoir, but it was her contact with Vuillard that proved the most fruitful. Starting out as a friend and model, the beautiful Misia soon stole the confirmed bachelor's heart. Vuillard, respectful and reticent, never declared himself openly, though, in canvases painted between 1895 and 1897, Misia's presence seems to transform his art. Vuillard abandoned the closed, chilly scenes of the Nabis* interiors,

and moved on to a more sensual, open universe inspired by her elegance. Sometimes represented at rest on a settee in the company of Thadée (*Misia and Thadée Natanson,* c. 1897) or rapt in concentration at the piano with Cipa at her side (*Misia at the Piano with Cipa Listening* [*Misia au piano et Cipa l'écoutant*], 1897), she is seldom portrayed on her own (*Portrait of Misia,* c. 1898). It is as if the painter, oscillating between reason and emotion, felt that a third party would confirm her unavailability (*Misia and Vallotton,* c. 1896). The clear-sighted Misia later told of a walk on the banks of the Yonne with the then twenty-nine-year-old artist that bears

Misia and Vallotton, 1899.
Oil on cardboard,
28 ¼ x 21 in.
(72 x 53 cm).
W. K. Simpson
collection, USA.

some likeness to a declaration. Distressed by the unyielding Misia, Vuillard confided in Vallotton*: "I work relentlessly to keep my spirits up; they are in a sorry state." Misia divorced Thadée, however, to wed Alfred Edwards, proprietor of the newspaper *Le Matin* and director of a theater, in 1905, before later marrying the painter José Maria Sert. She continued to hold Vuillard in great regard as a man who had offered her her "most beautiful declaration of love":

We left as evening was closing in, grave and dreamy, Vuillard leading me along the river flanked by tall silver-trunked birch-trees. I don't think we spoke.
He advanced slowly through the yellowing grass and, unconsciously, I respected his silence... The ground became uneven. I caught my foot in a root and half fell. Vuillard stopped in his tracks, helping me regain my balance. Abruptly our eyes met. I could only see his sad eyes shining in the darkening gloom. He burst into sobs—it is the most beautiful declaration of love a man ever made to me
(Sert, *Misia*).

▨ Neo-impressionism
Like Gauguin* determined to break with the empiricism of Impressionism*, in 1886 Seurat (1859–1891) developed Neo-Impressionism, also termed Divisionism or Pointillism (*Sunday Afternoon on the Île de la Grande Jatte*, 1886). Spurred on by Delacroix, by Chevreul's theories of complementary colors, and by Charles Blanc's ideas concerning expressiveness

of line, this approach, consisting of placing tones on the canvas in tiny separate brushstrokes, marked the onset of the intrinsic autonomy of artworks. Taken up by Pissarro, Paul Signac, and Henri-Edmond Cross, Neo-Impressionism attracted the attention of many painters, including the Nabis* and Vuillard. He would later have the chance to see works by Seurat at the Salon des Indépendants (1888 and 1889) and to meet him in the circle of *La Revue blanche**, which would be the forum for a posthumous show of his oeuvre in 1892. From 1890 to 1892, with the intention of "conceiving... a picture in the way of a cluster of chords, [and] moving away forever from the Naturalist idea" (*Journal*, August 1890), Vuillard experimented with many of Seurat's techniques (*The Garden* [*Le Jardin*], 1890–1892). He radicalized the approach, however, and often married Divisionist processes to the Gauguin-derived notion of applying pure reds, yellows, and blues that enrich the image with a mystical dimension. Unlike Seurat, Signac, and Cross, Vuillard's brushstrokes were large, to the point that they may blur the contours of objects and figures (*Grandmother at the Sink* [*La Grand-Mère à l'évier*], c. 1890–1891), sometimes being applied to abstract forms devoid of reference to reality (*The Longshoremen* [*Les Débardeurs*], c. 1890). Attracted primarily by the

decorative qualities of the technique, Vuillard also used it ornamentally in various zones of his Synthetist works (*On the Japanese Couch* [*Au divan japonais*], c. 1890–1891; *Octagonal Self-Portrait* [*Autoportrait octogonal*], c. 1891). From 1893 on, Vuillard deduced from these experiments an individual decorative schema that consisted of arraying brushstrokes in patterns on dresses or wallpaper (*Interior at the Dressmaker's/The Suitor* [*L'Intérieur à ouvrage/Le Prétendant*], 1893). Though short-lived, Vuillard's Pointillist phase allowed him to shake off the Naturalist yoke and create an original technique capable of sublimating decorative motifs from the domestic milieu that was his true inspiration (*Women with Pink Wallpaper* [*Femmes au papier peint rose*], 1895).

Grandmother at the Sink (La Grand-mère à l'évier), 1890. Oil on cardboard mounted on panel, 9 x 7 ¼ in. (22.5 x 18.3 cm). Private collection.

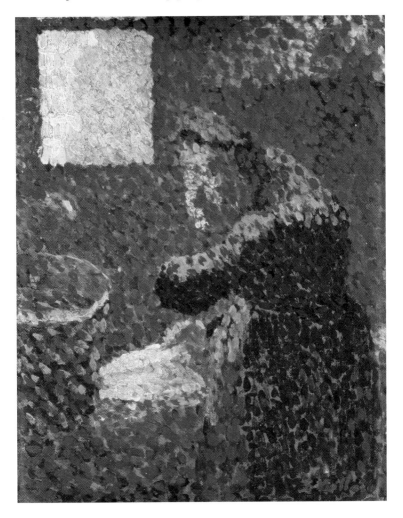

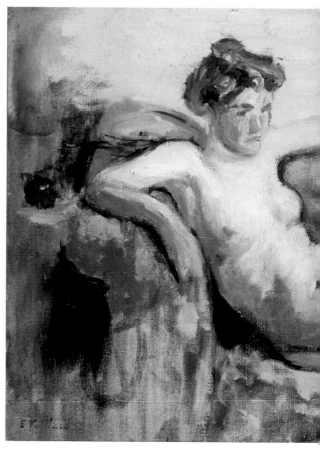

Reclining Nude on a Sofa (Nu étendu sur un canapé), 1903.
Oil on canvas mounted on panel,
11 ¼ x 17 ½ in. (28.5 x 44.5 cm).

■ Nudes

As an *intimiste* (see *Intimisme*), it was only natural for Vuillard to tackle the nude. Somewhat neglected by art historians, there are a significant number of these intimate works, even though the painter does not always seem wholly comfortable in the genre. Moreover, in a very early sketch he voiced his contempt for artists who reduce females to mere images (*Journal*; the sketch is annotated "painters of women," c. 1890). In point of fact, Vuillard's lifelong endeavor was to depict the inner beauty of Women (*Lucie Hessel before the Sea* [*Lucie Hessel devant la mer*], c. 1904). After some tentative art-school studies (*Nude*, 1888), from 1890 to 1900 the artist produced several Synthetic nudes (*Woman in an Interior* [*Femme dans un intérieur*], c. 1891–1892). A prudish spirit who as a rule painted in the house where he lodged with his mother, his nudes prior to 1909 betray a certain unease. Seldom completely naked (*Model Undressing in the Studio, rue*

Truffaut [*Modèle se déshabillant dans l'atelier, rue Truffaut*], c. 1903) or, if naked, viewed from afar (*The Folding Bed* [*Le Lit-cage*], 1900) or from behind (*The Hairstyle* [*La Coiffure*], c. 1908), the model is generally rendered indistinct by his Impressionist manner (see Impressionism). The nudes composed in the studio on the boulevard Malesherbes from 1909, however, are both more direct and more realistic. Turned three-quarters in her blouse, the model is now well-defined (*Model Undressing, boulevard Malesherbes* [*Modèle se déshabillant, Bd Malesherbes*], c. 1913) and sometimes presented in an acrobatic pose (*Interior with a Folding Screen* [*Intérieur au paravent*], 1911); from now on the sitter is viewed from close up and almost frontally, although the head may still be bowed (*Female Nude Woman before a Japanese Screen* [*Femme nue devant un paravent japonais*], c. 1912). One of these intimate scenes, in which a model of a certain age is enthroned on a settee, represents a clean break with earlier

examples (*Reclining Nude* [*Nu allongé*], 1919–1920). In this masterpiece of a realistic style, the artist offers an inestimable homage to the women who so often inspired him, testifying to the confidence he had acquired over time with regard to this theme. Far from evoking the sensual nature of nudity, like Bonnard*, or associating it with venal love, like Walter Sickert and Picasso, Vuillard differed from the majority of the artists of his generation by turning every picture into a hymn to freshness and, at a later juncture, to beauty.

■ Palais de Chaillot

Built on the occasion of the 1937 World Fair, the Théâtre de Chaillot offered the opportunity for Vuillard, Bonnard*, and Roussel* to collaborate once more on a mural. Although by then seventy years old, and in spite of unfavorable material conditions, in the panel entitled *La Comédie*, Vuillard exceeded himself. Salomon tells how, without a studio at his disposal, the artist had to wrestle with the vast composition (10 ft. 11.9 in. x 11 ft. 5.8 in. [335 x 350 cm]) on the floor in his apartment on place Clichy, where he found it difficult to envisage it as a whole. Moreover, due to a failure of organization, he was not even supplied with precise information on the intended site for the piece. Unruffled, Vuillard managed to produce an individual work that, although its situation above a door is hardly advantageous, breathes a certain poetry through the Classical edifice. In this new commission for the decoration of a public building, he naturally went back to Puvis de Chavannes*, adopting his allegorical mode. Forsaking his customary artistic vision, Vuillard created a fairylike domain: in the background can be glimpsed figures from the Italian comedy (Scapin) together with winged female dancers, while in front appear characters from Perrault's "Donkey Skin" (*Mother-Goose Tales*) and from Classical comedy. The whole scene is orchestrated by a little monkey gazing at his reflection (the symbol of Comedy) in a forest inspired by that at the Château de Clayes. This first wholehearted attempt at a work of the imagination (something the painter was to repeat the following year in *Peace Protecting the Muses* [*La Paix protectrice des Muses*] for the League of Nations*) seems to herald a new dawn in his art, brutally cut short by his death in 1940. Approaching the language of Roussel, Vuillard—like Bonnard—also wanted to bear witness to his admiration: although the central area had been reserved for his piece, he did not hesitate, after discussing the question with Bonnard, to bow before Roussel's decorative talent and exchange places with his friend (Salomon).

Paris

Parisian through and through, Vuillard, after his arrival in 1877, remained faithful to the capital for his entire life. Home-loving or simply contented, he seldom strayed, except for a few trips to the country (Normandy, Brittany) and visits to European cities (Venice, Geneva). As testimony to this affection, Vuillard offers the city the most magnificent homage of a creative mind by sublimating it through art. Unlike most painters of his generation, Vuillard's Paris is not the Bohemian and festive atmosphere of Montmartre or Montparnasse. He was instead more receptive to the poetry of its public parks (*Public Gardens* [*Jardins publics*], 1894), to the cityscape with its boulevards and streets (*Streets of Paris* [*Rues de Paris*], c. 1906–1908), to the easy comfort of its more desirable quarters (*Portrait of Princess Bibesco*, c. 1934–1935). His chosen home was the Right Bank, where he found ready inspiration in his own apartments: from rue Miromesnil, where he moved in 1887 (*Portrait of Mme Michaud*, 1888) to rue Saint-Honore in 1891 (*Interior at the Dressmaker's/The Suitor* [*L'Intérieur à ouvrage/Le Prétendant*], 1893) then rue Truffaut in 1899 (*Model Undressing in the Studio* [*Modèle se déshabillant dans l'atelier*], 1903). Equally devoted to the Right Bank and to his mother*, he chose to live in places that could provide him with subjects for his painting. In 1904, mother and son moved to 123, rue de la Tour, in the wealthy sixteenth arrondissement, where Vuillard started work on the first five of the panels (see Decorative Panels) for the playwright Henri Bernsteins In 1908, they moved nearer to his friends Bonnard* and Lucie Hessel*, who lived,

Square Vintimille, c. 1915.
Distemper on paper mounted on canvas, 2 ft. 5 ½ in. x 3 ft. 3 in. (75 x 99 cm). Private collection.

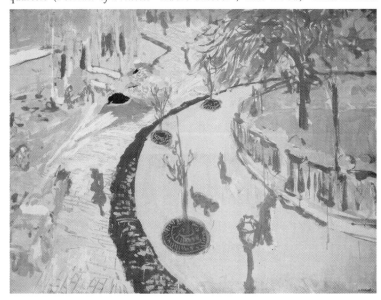

Facing page, bottom:
The Tree-Lined Avenue, Amfreville (L'Allée en sous-bois, Amfreville), 1907–1908. Distemper on paper, 3 ft. 10 ½ in. x 2 ft. 10 ½ in. (118 x 88 cm). Musée d'Orsay, Paris.

Below:
Pierre Bonnard, Grand-Lemps. Vuillard holding his Kodak camera, 1900. Musée d'Orsay, Paris.

respectively, on place Clichy and rue de Naples, taking up residence on rue de Calais. There he was to occupy two apartments, one after the other, the first of which—an extension of an apartment fitted out for Bernstein—overlooked the square Vintimille. Vuillard composed two bird's-eye views of the square (*Place Vintimille*, 1908); later, in 1911, the garden reappeared on the folding screen made for Princess Bassiano. The models invited to the second flat, which he occupied after 1913, generally posed in the living room (*Young Woman in Pink in the Living Room, rue de Calais* [*Jeune Femme en rose dans le salon de la rue Calais*], 1920). The quarter must have exerted a fascination over him; a year before the death of his mother, in 1927, he moved again to 6, place Vintimille.

Photography

Vuillard is just one of a host of late nineteenth-century painters who used photography in their art. Whereas predecessors like Degas had to make do with cumbersome apparatus (tripod camera, glass plates), Vuillard benefited from technical progress. Around 1890, he already possessed a Kodak portable (a model launched in 1888), with which he took numerous snapshots. The majority of his photographs are conserved in the Bibliothèque Nationale de France in Paris. He soon shared this enduring enthusiasm with his acolyte Bonnard*. Unlike the latter and many Symbolists (see Symbolism), Vuillard did not, however, regard photography as a genuine art form but rather as a memory aid. Tirelessly, he would capture the moments spent in the company of his muses Misia Natanson* and Lucie Hessel* in their apartments. Rarely without a camera, he would take photos of his friends at L'Étang-la Ville, Villeneuve-sur-Yonne, and

Vaucresson, writing in his journal* for November 4, 1907: "Enchanted with these photographs that awake a thousand memories in me." Though he did not take "artistic" photographs, he often employed prints as material for his paintings, as a backup to his sketches. Thus, for the deeply plunging perspective of *A Game of Cards at Amfreville* (*La Partie de cartes à Amfreville*, 1906), the artist relied on a photograph (*View from a Window at Amfreville* [*Vue de la fenêtre à Amfreville*], 1906) taken from a room he occupied in the Hessels' red château, although he repositioned the figures of Jos Hessel*, Tristan Bernard, Marthe Mellot, and the novelist André Picard in the image. For *The Tree-Lined Avenue* (*L'Allée en sous-bois*, 1907–1908), he transcribed a print called *Lucie Hessel and Her Dog on the Broadwalk at Amfreville* (*Lucie Hessel et son chien dans l'allée à Amfreville*, 1906–1907) into a painting from which his friend and her pet were expunged. Other works, following a slightly different process, were derived from a synthesis of a number of views. Vuillard took as a starting point an entire print (*L. Hessel and M. Aron in Front of a Haystack at Amfreville* [*L. Hessel, M. Aron devant une meule à Amfreville*], 1905) in composing *The Haystack* (*La Meule*, 1907–1908), into which he inserted Tristan Bernard in a pose derived from a different snapshot of the writer (*Tristan Bernard and L. Hessel in Normandy*, 1907). Similarly, his passion for photography

had repercussions on his pictorial work between 1900 and 1920. He experimented with unusual framings, in particular in *Mme Trarieux and her Daughters* (1912), where "the foreshortening of focal distance... almost throws the armchairs in front out of the image frame" (Cogeval, Vuillard *Le Temps détourné*). More gener-

Below:
Lucie Hessel on the Broadwalk at Amfreville, 1906–1907.
Private collection.

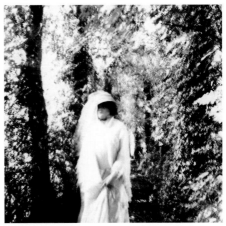

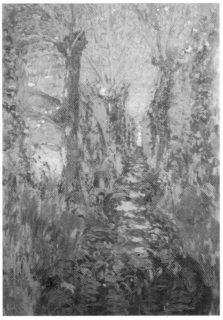

ally, the artist's novel interest would second his newly mimetic approach to the real, though, as he noted: "Painting will forever have the advantage over photography of being made by hand."

Pont-Aven, School of

At the end of the nineteenth century, Brittany, a far-flung region studded with timeless landscapes, attracted many artists searching for new subjects of inspiration. In the little village of Pont-Aven, located in the Finistère, lay the Gloanec *pension*, known among painters for its old-fashioned prices. Gauguin* stayed there for the first time in June 1886, before going to Panama and Martinique in 1887. Strengthened after his journeys in his resolve to create a more spiritual and internally vibrant art, Gauguin returned to Pont-Aven in the hope of finding suitable subject matter. He was quickly joined by several other artists, including Charles Laval and Émile Jourdan. The decisive encounter, however, was with Émile Bernard, whose "broad

flat tints... and vivid colors encircled by dark outlines '*cloisonnéed*' like stained-glass" (Terrasse) literally bewitched Gauguin, echoing his researches in the area of Japanese art and ceramics. In 1888, Bernard painted *Breton Women in the Meadow* (*Bretonnes dans la prairie*), a Synthetist manifesto to which Gauguin responded the same year with *The Vision after the Sermon/Jacob Wrestling with the Angel* (*La Vision après le sermon/La Lutte de Jacob avec l'ange*). By promulgating Synthetism—pure tones and forms in images that shun anecdote—and Cloisonnism—wide areas of color encircled by black outlines that disregard conventional perspective—and by appealing to the imagination and insisting on the spiritual dimension of art, the painters of the Pont-Aven school made a radical break with the objectivism of Impressionism*. In October 1888, Sérusier* met Gauguin and immediately made the tenets of the school his own. Following in the latter's lead, Sérusier created a celebrated work initially entitled *Landscape in the Bois d'Amour* (*L'Aven au Bois d'amour*, 1888). Immediately after his return from Pont-Aven (autumn 1888), this revolutionary piece was hailed as *The Talisman** by Denis*, Roussel*, Bonnard*, Ranson*, and Vuillard, leading directly to the development of Nabism (see Nabis).

Printmaking

With the rise of photography*, the function of printmaking and engraving,

Paul Gauguin, *The Vision after the Sermon*, 1888. Oil on canvas, 28 ¾ x 36 ¼ in. (73 x 92 cm). National Gallery of Art, Edinburgh.

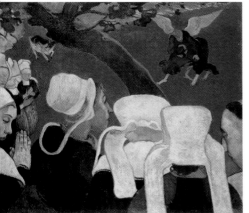

as well as that of painting, had to be reconsidered. Painters, who since Impressionism* had not confined themselves to simply aping reality, were now to rethink the purposes of printmaking too. Freed from its role as a purely reproductive medium (the origin of its popularity), it henceforth demanded all the artist's creativity. Manet and Jongkind soon published their works, before theatrical posters by Chéret, Mucha, and Lautrec publicized the technique of color lithography. This newfound vogue for the graphic arts could not but concern the Nabis* in their search of new outlets for their images. Dating for the most part from the Nabis era, Vuillard's lithographs generally appeared as illustrations for *La Revue blanche** (*Interior*, 1893; *The Dressmaker* [*La Couturière*], 1894) or as theater programs*. Except for some of the latter, most reflect the muffled, *intimiste* world (see *Intimisme*) of Vuillard's pictorial oeuvre. The extensive recourse to color wash in obtaining the harmonious tone characteristic of his pictures resulted in Impressionist works such as those in the album *Landscapes and Interiors* (*Paysages et Intérieurs*).

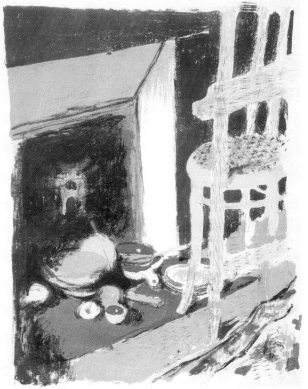

Landscapes and Interiors: The Fireplace (Paysages et Intérieurs : L'Âtre), 1899. Lithograph, 13 ½ x 11 in. (34.6 x 27.9 cm). Smith College Museum of Art, Northampton.

Published in 1899 at the behest of Ambroise Vollard, this last comprises twelve plates (*Interior with Pink Hangings I, The Game of Checkers, Interior with Hanging Lamp, Interior with Pink Hangings II, The Two Sisters-in-law, The Fireplace, The Cook, Interior with Pink Hangings III, Cake for Tea, On the Pont de l'Europe, Across the Fields, The Avenue* [*Intérieur aux tentures roses I, La Partie de dames, Intérieur à la suspension, Intérieur aux tentures roses II, Les Deux Belles-Sœurs, L'Âtre, La Cuisinière, Intérieur aux tentures roses III, La Pâtisserie, Sur le pont de l'Europe, À travers champs, L'Avenue*]), to which is added the cover. An unquestionable masterpiece, the album is one of the finest creations in all modern gravure. Nevertheless, as it met with little public appreciation, Vuillard and the Nabis were to abandon this novel form of expression. Having turned down a proposition to illustrate Proust's* *Swann in Love* (*Un Amour de Swann*), in 1934 Vuillard did agree to provide engravings for a recipe book by Henry-Jean Laroche entitled *Cuisine*. The same year Henry Marguery compiled a catalogue of his graphic work that comprised no less than sixty-seven plates. His corpus of prints also includes the odd etching, some of which were published in Jean Giraudoux's *Le Tombeau d'Édouard Vuillard* (1944), together with a poster dating from 1894 (*La Bécane*).

■ Programs (for the theater)

If none of the sets (see Sets and Scenery) Vuillard produced for the Théâtre de l'Oeuvre has survived, evidence of his contribution survives in the many programs for plays produced by the company, as well as by others, such as the Théâtre d'Art and the Théâtre-Libre. For this last, directed by Antoine, the artist planned a number of program illustrations of which only two seem to have actually been used: *Monsieur Butte* by Maurice Biollay (1891) and *Le Cuivre* by Adam and Picardy (1895). Among other projects there survives a *Pierrot* (c. 1891) in brush and ink and a number of colorful offerings inscribed with the name of the theater. Vuillard's style was more in keeping with the idealist spirit of Fort's* Théâtre d'Art, as abundantly demonstrated by his preeminently Symbolist (see Symbolism) *Concile féerique* (1891), for a play of the same name, which was reproduced in the journal of poetry and literature run by Fort (*Théâtre d'Art*).

Vuillard produced the greatest number of illustrations once he became responsible for programs at the Théâtre de l'Oeuvre, including those for French productions of Isben's *Rosmersholm, Pillars of Society, An Enemy of the People*; Hauptmann's *Lonely Lives*; Beaubourg's *La Vie muette*; and Björnson's *Beyond Human Might*. On the verso

of the illustration there generally appears a publicity drawing for *La Revue blanche*. Many programs borrowed material from his pictures: Hauptmann's *Lonely Lives* (1893) is an instructive example, the subjects being depicted as through a mist, much as in Vuillard's pictorial work of the period; similarly, the program for *La Vie muette* by Beaubourg (1894) takes as its starting point the series based on the theme of the public garden.

Vuillard's career as a designer of programs also allowed him to address dramatic subjects of a nature never hinted at in his paintings. The program for *La Vie muette*, for instance, shows, behind the mother embracing her child, the dangerously unhinged father poised to massacre his family. An illustration of a scene from Maurice Biollay's *Monsieur Butte* features the title character, having strangled his own maid, bent double and

Monsier Butte, Program for the Théâtre-Libre, 1891.
Ink on paper, 7 ¾ x 6 ½ in. (19.5 x 16.5 cm). Josefowitz collection, Lausanne.

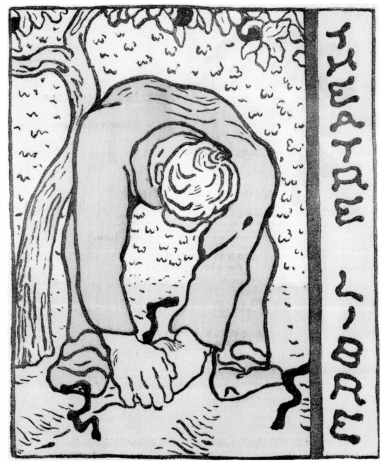

rubbing his hands on the ground. Finally, for the program for Beaubourg's *Image* (1894), Vuillard tackles the theme of murder head-on. Following the storyline of the drama—in which a writer determined to idealize his wife kills her, only to discover that the image of love lives on in her corpse—the program depicts the couple at the moment of the crime against an everyday backdrop.

■ Proust, Marcel

It seems that Proust (1871-1922) and Vuillard—both destined to become masters of the art of *intmisme,** and both pupils at the Lycée Condorcet—first met in the ambit of the *La Revue blanche** about 1895, at the dawn of their careers. Also sharing the same physician, Doctor Vaquez, they were soon to become friendly at the Paris salon of Princess and Prince Alexandre Bibesco, where they would have had occasion to spend time in one another's company. Two such meetings remained etched in the writer's mind: a dinner in the Bois de Boulogne organized by Antoine Bibesco in 1903, and a visit to Vuillard—then on vacation in Amfreville at the Hessels'*—while Proust was staying in the Grand Hôtel in Cabourg in August 1907. In 1904, Proust wrote to Bibesco requesting his assistance in purchasing a sketch Vuillard had made during the dinner—"the point of coincidence between his admirable talent which so often fertilizes my memory,

and a charming and perfect hour from my life." Recounting the visit in a letter addressed to his composer friend Reynaldo Hahn, Proust noted the painter's unexceptional appearance and easygoing tone: "A fellow like Titian, *n'est-ce pas?* knowing as much as Monet, *n'est-ce pas?*" He then adds that, in spite of this, Vuillard was a "rare being." In "fertilizing his memory," meetings with the painter naturally made their way into his book. An example is the remarks made by Elstir, the painter in *In Search of Lost Time* (À *la recherche du temps perdu*), which are strikingly similar to the preceding: "'Believe me, the fellow who carved this frontage,' said Elstir, 'was as strong, had ideas just as deep as the people today you so much admire'" (Preston, *Édouard Vuillard*). Inspired by Whistler—a quasi-anagram of Elstir—Monet, Degas, and Manet, the character borrowed many qualities from painters that Proust frequented around 1900, among them Paul Helleu, Sickert, and Vuillard himself (Thomson, *Vuillard*). Having sought happiness in society, in love, and in works of art, the narrator of the *Search* finally finds it by chance, after dunking a *madeleine* cake in his tea, an act that brings memories of childhood flooding back.

The same duality, the joint quest for the unfamiliar and for the known, can be found in Vuillard: leaving aside society, his muses, and his study of the masters, he never failed to seat his models in comfortable surroundings that surely

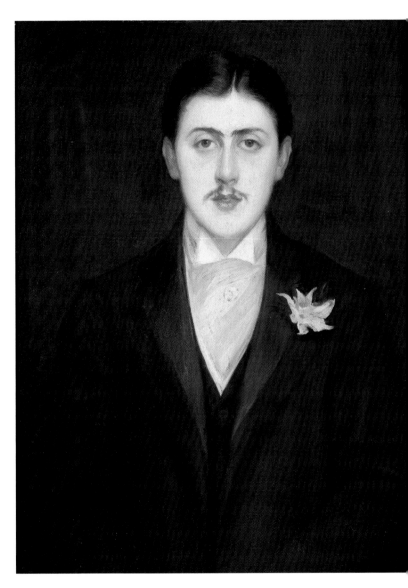

reminded him of the maternal home. "Why is it that our spirit and sensitivity find most easily the genuinely new in familiar places?" he asked in his 1893 journal*. In 1897, he explained to Denis*: "My sole guide is my instinct, the pleasure or, better, the satisfaction I find." The words "genuinely new" are thus to be understood as incitement, pleasure, and, by extension, recollection. Though Proust and Vuillard were scarcely on intimate terms, few minds have possessed such affinities in their creative endeavors.

Jacques-Émile Blanche, *Marcel Proust*, 1892. Oil on canvas, 29 x 23 ¾ in. (73.5 x 60.5 cm). Musée d'Orsay, Paris.

■ PUBLIC GARDENS (JARDINS PUBLICS)

Designed at the outset to decorate the walls of the dining or living room of Alexandre Natanson's* mansion at 60, avenue du Bois (today avenue Foch), this famous interior was dispersed at the sale of the patron's collection at Drouot's in 1929. The *Gardens* series numbers nine panels comprising one triptych—*The Nursemaids, The Conversation*, and *The Red Sunshade* (*Les Nourrices, La Conversation*, and *L'Ombrelle rouge* [Musée d'Orsay])—

and three diptychs—*Little Girls Playing* and *The Interrogation; The Two Schoolboys* and *Under the Trees; The Walk and First Steps* (*Les Fillettes jouant* and *L'Interrogatoire* [Musée d'Orsay]; *Les Deux Écoliers* [Musées Royaux des Beaux-Arts de Belgique, Brussels] and *Sous les arbres* [Art Museum, Cleveland]; *La Promenade* [Museum of Fine Arts, Houston] and *Les Premiers Pas* [whereabouts unknown]).

Created in 1894, the series was typical of the decorative ensembles the

Public Gardens, (Jardins publics), 1894. Distemper on canvas. *The Nursemaids (Les Nourrices)*, 6 ft. 11 ½ in. x 2 ft. 7 ½ in. (212 x 80 cm); *The Conversation (La Conversation)*, 7 ft. x 5 ft. ½ in. (213 x 154 cm); *The Red Sunshade (L'Ombrelle rouge)*, 7 ft. ¼ in. x 2 ft. 8 in. (214 x 81 cm). Musée d'Orsay, Paris.

At the Tuileries [Aux Tuileries], 1897–1900).

Around this time, Vuillard reflected long and hard on the Nabis style and his innovative works deploy processes borrowed from the movement's forerunners. He also alluded to the master of the fresco, Puvis de Chavannes*, in the flattened, formal transposition of a real landscape, solutions that Vuillard had already been exploring in the Japanese print. In the spirit of the same master, he exploited a discovery he had made at the Théâtre de l'Oeuvre: the luxuriant, fresh matte effect of a glue medium that gives the impression that the paint was applied directly to the wall. Doubtless both subject and lighting effects were inspired by Monet's *Women in the Garden* (*Femmes au jardin*, 1867), but rather than an impression of time passing, time is frozen as in snapshot. A synthesis combining audacious exploration with a taste for the timeless, this substantial series illustrates the freedom the artist had gained from the Nabis movement. In spite of a lack of experience in the domain, he imposes himself as a veritable master of the decorative panel*, a talent that later works would only confirm.

Nabis* created with the idea of situating art at the heart of life. Vuillard obviously never lost sight of this aim, since between 1892 and 1920 he created many interiors for private houses. The artist's second commission, this interior was his first large-scale creation. In it he depicts homely, everyday scenes—taking place in a park undoubtedly inspired by the Tuileries and the Luxembourg gardens—that endow the landscape with an intimate character (as with

▪ Puvis de Chavannes, Pierre

Master of the grand decorative scheme, Pierre Puvis de Chavannes (1824–1898) attracted the notice of the Symbolists (see Symbolism), Gauguin*, and the Nabis*, as well as of Vuillard himself. It is not beyond the bounds of possibility that Puvis paved the way for Vuillard to become a painter. Maurice Denis* suggested that Vuillard might have glimpsed Puvis—also from Cuiseaux in the département of Saone-et-Loire— when he came to pay his tax to Vuillard's father, at the time revenue inspector for the small town.

Linked to the artist by a common origin, Vuillard was as fascinated by his easel works as by the murals he carried out for public buildings throughout France (*Le Bois Sacré* in the Sorbonne and *The Life of St. Genevieve* in the Pantheon) and abroad. In keeping with a classical education enriched by the study of Quattrocento fresco painting, Puvis's language was essentially allegorical. His canvases are possessed of an exemplary simplicity of tone that reveals a preoccupation with flatness, and a corresponding absence of modeling in which motionless figures are overlaid with spirituality. Such characteristics (*The Poor Fisherman* [*Le Pauvre pêcheur*], 1881; *Sweet Country* [*Doux Pays*], 1882) emerged from a dialogue between easel and wall painting, and gave rise to pictorial qualities for which both the Symbolists and the Nabis (many of whom were to fulfill mural commissions for the French state) were searching. By studying Puvis's work, Vuillard learned how to translate in a planar and formal construction the three-dimensional vision of the landscape before him (the Desmarais panels, 1892; *Public Gardens* [*Jardins publics*], 1894). Especially receptive to matte tones close to the fresco effects deployed by Puvis, the "prophets" abandoned the

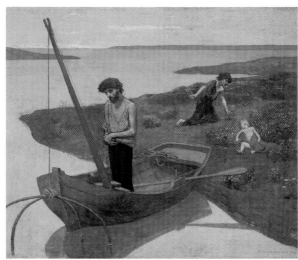

Pierre Puvis de Chavannes, *The Poor Fisherman*, 1881. Oil on canvas, 5 ft. 1 in. x 6 ft. 3 in. (1.55 x 1.925 m). Musée d'Orsay, Paris.

sheen characteristic of oil paint. Vuillard attained the required effect by the use of *peinture à la colle*—pigment mixed with hot glue—a process he had discovered scene painting for the Théâtre de l'Oeuvre (see Theater). Vuillard admired Puvis more than any of the Nabis and he never ceased interrogating his work—unlike with Gauguin*, of whom he rapidly tired (1890–1891). When commissioned to paint murals for the Palais de Chaillot* (1938) and for the League of Nations* (1938), he once more returned to the master, employing allegory in what was a novel departure for his art.

■ Ranson, Paul

Although of very different aspirations and temperaments, the bonds of friendship between Vuillard and Ranson (1861–1909) endured from the former's entry to the Nabis* clan until the latter's death. After training at the school of decorative arts in Limoges, Ranson settled in Paris, enrolling at the Académie Julian in 1886 and joining the core of the Nabis, with Denis*, Sérusier*, and Bonnard*, in 1888. Subsequently, "the Nabi more *Japonard* than the *Japonard* Nabi [i.e. Bonnard]" (see Japonism) produced works that explored the decorative in a marriage of arabesques and bright colors (*The Attic* [*La Mansarde*], 1893), or else evocative of some unseen evil power (*The Witch and the Cat* [*La Sorcière et le chat*], 1893). After joining the clan in 1889, Vuillard went to many of the gatherings in Ranson's studio

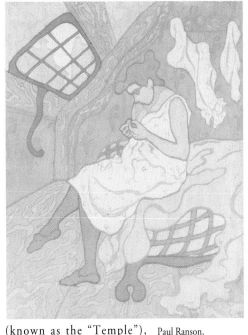

(known as the "Temple"), where, in the summer of 1890, Ranson would "perform all kinds of syntheses" (Salomon). The tone of these at once spiritual and entertaining get-togethers was set both by Ranson and his wife France, "the Muse of the Temple." Expert in esotericism and theosophy, even sorcery, Ranson encouraged his guests to sport togas and speak in an overblown idiom in keeping with their status as members of a brotherhood (Sérusier, *Paul Ranson en costume nabique*, 1890). Less than convinced by these games, Vuillard nonetheless played his part. He seems to have been more interested in the theatrical talent of a host who regaled his guests with an invented character called Abbé Prout and his anti-bourgeois dialogues. It was in this context that the Nabis' thespian

Paul Ranson, *The Attic (La Mansarde)*, 1893. Oil on canvas, 21 x 17 ¾ in. (53.5 x 45 cm). Josefowitz collection, Lausanne.

experiments began. The Théâtre des Marionnettes soon followed, for which Vuillard often built the sets (see Sets and Scenery), in particular for Maeterlinck's play *The Seven Princesses*, performed in 1892 in the house of Coulon, a member of the Conseil d'État. During this period, Ranson visited the studio of Vuillard and Lugné-Poe*, through whom they were to begin working first in the Théâtre d'Art then the Théâtre de l'Oeuvre. Both interested in decorative art*, the painters responded to Siegfried Bing's plans to promote the style of his gallery, La Maison de l'Art Nouveau: in a dining-room decorated by Ranson in the spirit of the gallery (*Three Women at the Harvest* [*Trois femmes à la récolte*], 1895), Vuillard showed some plates side by side with projects for stained glass produced by Tiffany. After the Nabis period had come to an end, in 1908 Ranson opened an Academy* in which Vuillard, Vallotton*, Sérusier, and Denis all taught.

■ Realism

Discussing the *Portrait of the Countess Anna de Noailles* (1932), the painter and critic André Lhote proclaimed that it constituted "an insult proffered by the painter on his own work" (*La peinture libérée*, 1948). Of the opinion that innovations in modern painting ought necessarily to concern themselves with reviving its "plastic invariants," he took a dim view of Vuillard's return to Realism after 1900.

Throughout his career, even when he belonged to the avant-garde, Vuillard had always displayed this tendency. Thus, exhibiting little propensity for working in the antique mode (*The Death of Cesar*, 1885), he fell back on Chardin and Corot, painters closer to his own cultural reality (*Still Life with Salad* [*Nature morte à la salade*], 1887–1888). Rejecting the rules of traditional composition, the Nabi* Vuillard did not subscribe to the group's mystical inclinations, however, adumbrating a personal interpretation of Symbolism* that consisted first in synthesizing, then in suggesting, perceived reality. After 1900 and in the light of Impressionism*, he would forsake the Symbolist manner, and revert to representing space and the subject in accordance with Albertian tenets. After 1930, Vuillard subjected reality to near-obsessive scrutiny in society portraits (see Society Portraiture) of an exacerbated Realism. An anecdote concerning the portrait Lhote lambastes above offers confirmation: before taking up her pose, Anna de Noailles instructed her chambermaid to remove the pot of Vaseline lying on her bedside table, adding, "Vuillard paints everything he sees." Profoundly involved with his immediate environment, the painter would only change his way of looking at the world during periods of crisis—be they personal (Nabism) or external (war; see Travels, League of Nations, Palais de Chaillot).

Facing page, top :
Portrait of Jeanne Lanvin, c.1933.
Distemper on canvas, 3 ft. 3 in.x 4 ft. 5 ½ in. (1.245 x 1.365 m).
Musée d'Orsay, Paris.

Facing page, bottom:
Madame Adrien Bénard.
3 ft. 9 ¾ in. x 3 ft. 4 ¼ in. (1.145 x 1.025 m).
Musée d'Orsay, Paris.

One can of course regret the painter's later development, but this would be to ignore the fact that it was thanks to Realism that Vuillard bequeathed some of the most beautiful illustrations ever painted of the elite Parisian lifestyle in the first half of the twentieth century. Indeed, this invaluable testimony would never have seen the light of day in the context of emotionally charged Fauvism or intellectualized Cubism, in abstraction's pure imagination or Surrealism's unconscious drives.

■ **Redon, Odilon**. See Symbolism

■ REVUE BLANCHE, LA

Following his introduction to the world of the stage, Vuillard's collaboration on the *Revue blanche* gave him an entrée into literary circles. Founded in Belgium in 1889 by the Natanson brothers*, in 1891 the journal moved to Paris (rue des Martyrs). Alexandre took charge as manager, with Thadée as editor-in-chief, Alfred penning the diary pages (under the pseudonym "Alfred Athis"), and Felix Fénéon in the editorial office. An avant-garde publication, it not only supplied French-speaking readers with the very latest in foreign literature but also provided a forum for aesthetic debate in both the pictorial and musical fields. Columns signed by prestigious names such as Marcel Proust*, poets Apollinaire and Mallarmé*, novelists Octave Mirbeau and Jules Renard, playwrights Tristan Bernard and Romain Coolus, and critic and politician Léon Blum were adorned with lithographs by many artists, including Vuillard and the Nabis*. After meeting Vuillard in 1891, the Natanson brothers were seduced by his pictorial world and published his first lithograph in July 1893: *Interior* (see Printmaking). Vuillard was soon joined by Bonnard*, Sérusier*, and Denis*, and the *Revue blanche* thus became the prime outlet for Nabis art, with Bonnard creating a much-reproduced advertising poster (*La Revue blanche*, 1894). Precocious in their defense of the "prophets," the Natansons—themselves art collectors—even put on the Nabis' debut exhibitions in the entrance hall of the editorial office (by then located at 1, rue Lafitte). In a spirit of mutual aid and encouragement, these collaborators-cum-friends continued their debates in La Grangette at Valvins,

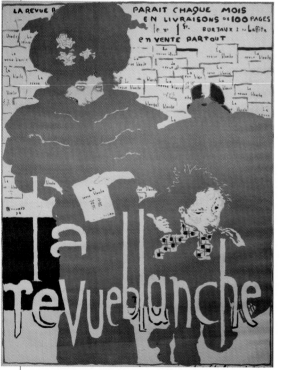

near Fontainebleau, and at the Relais in Villeneuve-sur-Yonne, where Thadée Natanson lived. Spurred on, it should be said, by the presence of Thadée's beautiful wife Misia*, his future muse, Vuillard seems to have blossomed in this intellectual and artistic hotbed. As well as publishing many lithographs, the review gave Vuillard the chance to meet the most brilliant young minds of the time, as well as Redon and Seurat, then close to the Natansons. Unfortunately the adventure came to an abrupt halt in 1903 when financial difficulties forced the review to fold.

Pierre Bonnard, *La Revue blanche*, 1894. Lithograph. Bibliothèque Nationale de France, Paris.

■ ROUSSEL, KER XAVIER

Though they came from very different family backgrounds, Vuillard and Roussel formed a friendship at the Lycée Condorcet* (1883) that proved crucial for their future careers. Born at Le Chêne (near Lorry-lès-Metz), Ker Xavier Roussel (1867–1944) settled with his parents in Paris in 1870. Son of a wealthy, art-loving physician, Roussel discovered his calling during lessons with the academic painter Maillart, a friend of his father. Naturally romantic and extroverted, he fascinated Vuillard, convincing his friend to give up his plans to attend the Saint-Cyr military school and to join him instead in his master's studio (1885). Enrolled at the Académie* Julian in 1888, both Nabis* rallied to *La Revue blanche**. Comforted by the Vuillard family following the divorce of his parents, Roussel grew close to Vuillard's sister Marie, marrying her in 1893; a daughter, Annette, arrived in 1898.

In tandem with Vuillard, he studied Chardin (*Still Life with Onions* [*Nature morte aux oignons*], 1888), Puvis de Chavannes (*The Miraculous Draft of Fishes* [*La Pêche miraculeuse*]), and Corot (*Christ with the Children* [*Le Christ aux Enfants*]), as well as Poussin (*The Good Samaritan* [*Le Bon Samaritain*], c. 1892). As a Nabi, he started working in the decorative* and graphic arts (*The Landscape Album* [*L'Album du paysage*], 1899). Sometimes close to Vuillard's (*Woman in a Speckled Dressing-Gown* [*La Femme au peignoir moucheté*], c. 1892), his works at this time are more generally evocative of Denis* (*The Virgin on the Path* [*La Vierge au sentier*], c. 1890). Though he could draw inspiration from Gauguin* and Japonism* and was attuned to the poetic universe of Symbolism*, Roussel quickly tired of the small formats and unvarying subjects of the Nabis, finding himself more in keeping with the *intimiste* style (see *Intimisme*) of Bonnard and Vuillard.

Although separated from his brother-in-law following a move to Étang-la-Ville in 1899, Roussel continued to be enriched by his meetings with Vuillard.

Exhibitors at the Salon des Indépendants (1901) and the Salon d'Automne (1903 and 1904), they also both taught at the Académie Ranson (1906). If Vuillard's *intimiste* Realism is far removed from Roussel's mythological scenes, stylistically they seem compatible. Together, they decorated the Comédie des Champs-Élysées (1913), then the League of Nations in Geneva (1937) and the Palais de Chaillot (1938), where Vuillard's allegorical tenor resembles his friend's. After Vuillard's death, the Roussels donated fifty-five of his works to the French government, including hitherto little-known pieces (*In Bed* [*Au lit*], 1891), which were unveiled at the exhibition devoted to the artist in the Orangerie (1941–1942).

Portrait of Ker Xavier Roussel/The Reader (Portrait de Ker Xavier Roussel/Le Liseur), c. 1890.
Oil on canvas, 13 ¾ x 7 ½ in. (35 x 19 cm).
Musée d'Orsay, Paris.

■ Self-Portraits

The many self-portraits Vuillard executed throughout his career testify to a predilection for the genre. Unlike those of Cézanne (*Self-Portrait*, 1875, Musée d'Orsay), which resound like paeans to the artist's narcissism, Vuillard's reflect the unassuming and unsophisticated nature of the painter as he is often described by those who knew him well. If they predictably recapitulate his stylistic evolution (from Naturalism, through the Nabis* period and Impressionism*, to Realism*), they also constitute—in conjunction with his private journal*—the most fruitful way of coming to understand a man who never wore his heart on his sleeve. Of a grave demeanor in early examples—his father had died when he was only fifteen (*Self-Portrait Wearing a Boater Hat* [*Autoportrait au canotier*], c. 1888)—later depictions show him in the stiff attitude of a man bent on self-control (*Self-Portrait*,

c. 1892). After 1900, he appears more relaxed, seemingly reconciled to his intuitive temperament (*Self-Portrait*, 1903). The self-confident *Portrait of the Artist Washing his Hands* (*Portrait de l'artiste se lavant les mains*, 1924) is apparently free of any propensity to self-examination. Depicted in motion, he no longer seems determined to control his self-image at all costs. His self-portraits, though useful in what they tell us of his state of mind, are less forthcoming when it comes to his innermost feelings—except for the *Self-Portrait with the Artist's Sister* (*Autoportrait avec la soeur de l'artiste*, c. 1892), in which the joy Vuillard experiences in embracing his sister is manifest. Respectful of his sitters, when applying some new technique (such as Gauguin's* Synthetism), Vuillard, unlike Picasso, opted for self-portraiture, as if to avoid distorting the image of his model (*Octagonal Self-Portrait*, c. 1891). Works hinting at his immediate environment are rare indeed: relying on closely framed views (*Octagonal Self-Portrait*), on darkness (*Self-Portrait with Waroqui*, 1889), or on mirror images (*Self-Portrait in a Mirror*, 1888–1890), little of the space in which he lived and moved ever transpires, though the *Portrait of the Artist Washing the Hands* presents a glaring exception. Depicted in his brightly lit bathroom, here one discovers some of the

Facing page:
Self-Portrait. Study of a Face (*Autoportrait, étude de visage*), c. 1889.

Oil on canvas, 9 ½ x 7 ½ in. (24.5 x 19 cm). Musée d'Orsay, Paris.

Below:
Octagonal Self-Portrait (*Autoportrait octogonal*), c. 1890.

Oil on cardboard, 14 ¼ x 11 in. (36 x 28 cm). Private collection, Paris.

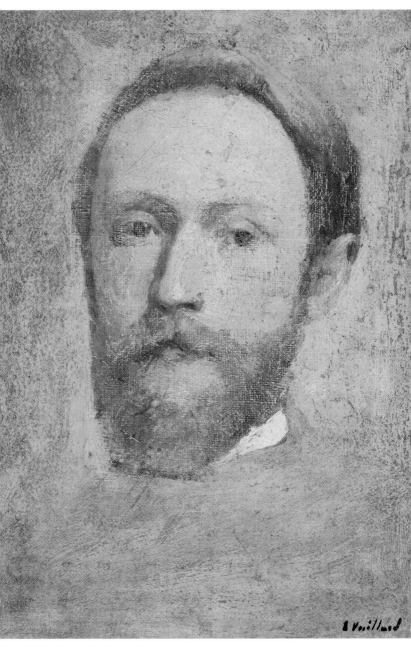

artworks among which he liked to live and which he never ceased analyzing: a view of Edo by Hiroshige, Michelangelo's *Zachariah*, the *Flora* of Stabia, and *Raymond Diocrès Speaking after his Death* by Le Sueur (Dumas and Cogeval, *Vuillard*).

■ SÉRUSIER, PAUL

The friend with the flaming beard
The majority of the Nabis*
acknowledged their debt to Paul
Sérusier, whom Denis* describes as
"an intellectual and artistic guide"
(*Paul Sérusier*, 1942). Converted
to the new aesthetic, Vuillard had
no hesitation in calling 1890 "the
year of Sérusier" in his journal*.
Born in Paris in 1863, Sérusier was
a brilliant student who spent his free
time composing verse plays accom-
panied by decorations. Enrolling in
1885 at the Académie* Julian, he
was awarded a *mention* at the Salon
of 1888 for his *Breton Weaver's
Workshop* (*Atelier de tisserand bre-
ton*). In October he sojourned in
Pont-Aven*, returning with *Land-
scape in the Bois d'Amour* (*L'Aven
au Bois d'amour*), executed under
instructions from Gauguin*. This
work became *The Talisman** for
fellow-members of the school and
marks the inauguration of Nabism
(see Nabis). Nicknamed the "Nabi
with the flaming beard," he belongs

to the esoteric branch of the movement, the one most faithful to the spirit of Gauguins H
schematic works evoke the simplicity and piety of Brittany (*Breton Ève/Melancholy*, [*È
bretonne/La Mélancolie*], 1890; *Three Breton Women Walking on the Strand* [*Tr
Bretonnes marchant sur la grève*], c. 1890). Following a taste for theosophy—reinforc
during a stay in 1896 with Jan Verkade, who had become a monk—and rediscovering ea
Italian painting, Sérusier evolved an aesthetics based on the rule of the "sacred measure"
the Golden Section (*Christ in Majesty*, 1913). Though this tendency aroused the inter
of Denis and Ranson*, it left Bonnard*, Vuillard, and Roussel* unmoved. Sérusier grad
ally began to migrate to Brittany, settling there definitively in 1894.

Although their styles were at odds, Sérusier and Vuillard shared a passion for the stage (s
Theater), and they worked together on the Théâtre des Marionnettes in Ranson's stud
Later, once Sérusier had met Lugné-Poe* in the workshop on rue Pigalle in 1891, th
collaborated at Antoine's* Théâtre-Libre, at Fort's* Théâtre d'Art, and at the Théâtre
l'Oeuvre—where Sérusier, like Vuillard, was acclaimed as a "master of the program .
[and] of sets that number among the most splendid documents of our time" (Lugné-P
La Parade I). A fervent admirer of Vuillard, he nostalgically recalled his working pra
tices: "Wielding a great brush drenched in paint [he] seemed to throw the colors abo
haphazardly; yet, once they dried, it was magnificent" (*ABC de la peinture*).

Sérusier to Denis: "For the future, I dream of an utterly pure brotherhood compris
uniquely of committed artists in love with the Good and the Beautiful who will instill
their works and their demeanor that indefinable quality I call 'Nabi.'"

Paul Sérusier, Program for the Théâtre-Libre. Third show from the 1893–1894 season.

■ Sets and Scenery

It was the Nabis*—aided and abetted by Camille Mauclair and Pierre Quillard, whose ambition was to create sets "designed like a picture"—who made collaboration between artists and the performing arts common practice, blazing a trail that would be later exploited to the full by Robert Delaunay, Picasso, and Matisse. Anxious to break down the barriers between "craft" and "art" observed by previous generations, the Nabis were only too glad to answer appeals for stage sets from Paul Fort* and Lugné-Poe*. Vuillard, more than any other, benefited from these collaborations, which proved of enduring importance to his art. It was Vuillard who was responsible for the greater part of the often wonderfully colorful and inventive sets for the Théâtre de l'Oeuvre, which, although they have all since been destroyed, struck audiences forcibly at the time. In 1894, for instance, for Henri de Régnier's *La Gardienne*, he hung a tulle veil that divided the stage from the audience. The same year, for Ibsen's *Master Builder*, the stage was designed on an inclined plane like that which had already appeared in

The Goose (L'Oie),
c. 1890.
Oil on cardboard,
8¾ x 10 ½ in.
(22 x 27 cm).
Private collection,
Paris.

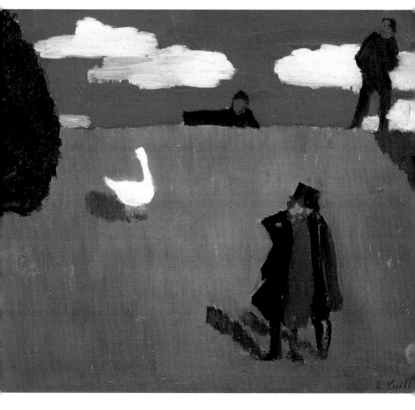

The Goose (*L'Oie*, 1890). Conforming to the spirit of Symbolist literature (see Symbolism), Vuillard's revolutionary reworking of stagecraft was instrumental in dematerializing the actors' performance and plunging them into an unrealistic atmosphere. Initially poorly received, the raked stage was to prove inspirational to German Expressionist theater (Cogeval, *Vuillard Le Temps détourné*) as well as to Soviet innovations: "Actually, what has recently been revived in Paris is nothing less than the stage for Meyerhold's *Government Inspector*" (Lugné-Poe, *Parade II*).

In the theater*, Vuillard benefited on two fronts: his training as a painter helped him as a stage designer, while his experience in the latter area gave his art a more personal stamp. In his Synthetist works, he created dramatic effects through the use of artificial light (*Dinner Time* [*L'Heure du dîner*], c. 1891) and replaced the medium of oil by pigment mixed with glue, just as he had done for sets and scenery (*Woman in a Bar* [*Femme dans un bar*], c. 1893–1895). Simultaneously, he broadened his scope to include applied art and interiors. Although he ceased working for the theater in 1895, he continued to compose pictures as if they were stage sets. Wholeheartedly embracing the technique of tempera, and methodically arranging his models in accordance with spatial construction, he reverted to Realism*, meticulously reproducing the interiors in which his subjects sat. Recognized as a master of decorative painting (see Decorative Arts), he was to receive many state commissions (Théâtre des Champs-Élysées*, League of Nations*, Palais de Chaillot*).

The scene known as "Mrs Solness' Dolls" raised a howl of protest. For this act, Vuillard, who liked the play as much as Maeterlinck, created a set of incomparable splendor... but the audience gazed on it like ducks staring at a knife. It was the first time in France that someone dared to set up a raking stage on trestles, vis-a-vis the audience, representing the terrace in front of the Solnesses' house. On these boards, the actors, partially visible as they moved one behind the other, were swamped in autumnal foliage. Not a single face was hidden. The players could not have been totally at ease, but so what! Everyone complained, I stood firm...»
(Lugné-Poe, *La Parade II*)

■ **Seurat, Georges**. See Neo-Impressionnism

◼ "SOCIETY"

The most sought-after portraitist of Paris high society, Vuillard, like Proust* and Balzac, left some of the most splendid images of that long-vanished world. It was after 1900, as he grew closer to the Hessels*, especially the eminently fashionable Lucie*, that Vuillard entered upper-middle-class and aristocratic circles. Simultaneously, he began to be known to a certain elite not only through exhibitions at Bernheim-Jeune* from 1900 to 1914, the Salon des Indépendants from 1901 to 1910, and the Salon d'Automne from 1903 to 1912, but also through the appreciative press coverage he was receiving. "A *intimiste* of rare delicacy," assured the influential Camille Mauclair (*Les Néo-impressionnistes*, 1904); "the greatest colorist of his time," concluded *Art et Décoration*'s François Monot in 1905 (quoted in Thomson, *Vuillard*). This favorable reception, combined with the need for art collections to rebuild after the dilapidation of the First World War, meant it was easier for Vuillard to gain acceptance among the elite. Their patronage was more profitable than that of art dealers who took a hefty cut, and the painter was to devote an increasing amount of his time to fulfilling more than forty commissions between 1920 and 1940, with sittings generally taking place in the patron's residence (see Society Portraiture). Among his clients were the actresses Yvonne Printemps (*Yvonne Printemps and Sacha Guitry*, 1922) and Jeanne Renouart (*Portrait of Jeanne Renouart*, 1927), whom he featured in flattering likenesses, and the important *couturière* Jeanne Lanvin (*Portrait of Jeanne Lanvin*, c. 1933) and her daughter (*The Countess Marie-Blanche de Polignac*, c. 1932), depicted in a more Classical manner. Treated to an almost Fauvist handling, the Countess de Noailles (1932) is portrayed in her bed where she usually worked. The banker David-Weil is shown before a collection of paintings that included many Chardins (*Portrait of David-Weil*, c. 1930), while the celebrated caricaturist of Parisian life, Forain, is captured in the act of painting (*Souvenir of a Last Visit to Forain* [*Souvenir d'une dernière visite à Forain*], c. 1928). But Vuillard also painted his friend Princess Bibesco; Jean Giraudoux; the powerful magnate Rosengart; the owner of the newspaper *L'Ère nouvelle*, Abel Gaboriaud, and his wife; Doctor Wildmer; and others.

Lucien Rosengart at his Desk (Lucien Rosengart à sa table de travail), 1930. Oil on canvas, 3 ft. ¼ in. x 4 ft. 10 ¼ in. (1.15 x 1.48 m). Musée des Beaux-Arts, Nice. From the Musée d'Orsay Collection.

■ SOCIETY PORTRAITURE

nterested in portraiture from early in his career, after 1912 Vuillard devoted the major part of his activity to the genre, specializing in the formal portrait. Between 1920 and 1940 he executed no less than forty portraits of middle-class and aristocratic personalities, many of them wealthy writers, musicians, actors, princes, dress designers, ministers, and financiers among whom the Hessels* moved. Known to this public through several exhibitions and through works hanging in the salons of his patrons, the artist became the most sought-after painter in Paris Society*. As he was by now almost exclusively engaged in fulfilling such commissions, his style evolved towards a tighter Realism*. From this point, his work was not only a far cry from the Synthetist research of the Nabis*, it was also quite unlike that of avant-garde artists such as André Lhote, Picasso, and Robert de La Fresnaye, who would, however, when their turn came, contribute to the post-war "return to order." From 1912 to 1930, he took the occasional poetic license (Madame Hessel Lying on a Couch [Madame Hessel étendue sur le divan], c. 1920), though space was now organized along perspectival lines. Later, from 1930 through 1940, he abandoned allusion and stylization for eminently realistic paintings that abound in details that appear to have been scrutinized with near-neurotic intensity (Portrait of Jeanne Lanvin, c. 1933). "Off to Mme Lanvin to measure the books; still some rather serious mistakes," he noted in his journal in 1933.

Perhaps, as several critics have proposed since 1945, he yielded to his clients' more conventional demands through insecurity. It would seem, however, that the artist had specific aims not unconnected with his earlier works and quite different from other portraitists of his time. When asked about these pieces, he answered: "I don't make portraits; I paint people where they live." Like Duranty, in order to capture the life of his models, he felt they ought not to be divorced from their setting. This is successfully achieved in the Portrait of Jeanne Renouart (1927) and in the Lucien Rosengart at his Desk (Lucien Rosengart à sa table de travail, 1930), in which the psychology and profession of the subjects can be discerned from every detail of the room: the actress in her dazzling dress surrounded by looking glasses; a carefully organized universe behind closed windows for the magnate. Yet more importantly, through these "late portraits"—in a process that enabled him to highlight the fabrics,

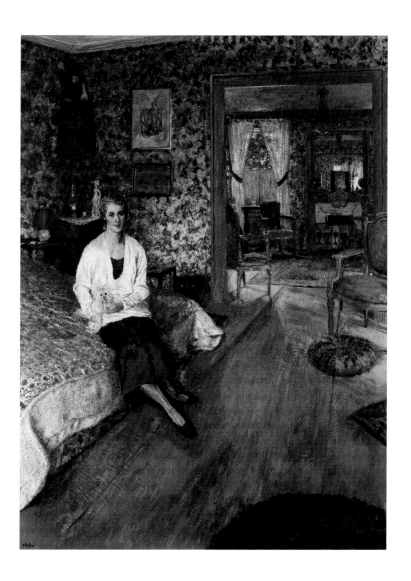

wallpaper, and artworks owned by
the clients (*Princesse Bibesco*, 1935;
David-Weil, c. 1930)—Vuillard
could continue in his search for an
equivalent of Proust's* *madeleine*.

Portrait of the Countess Marie-Blanche de Polignac,
1928–1932. Distemper on canvas,
3 ft. 8 ¾ in. x 2 ft. 11 ¼ in. (116 x 89.5 cm).
Musée d'Orsay, Paris.

■ Still Life

Vuillard, who admired seventeenth-century Dutch and eighteenth-century French painters, could hardly avoid tackling the still life genre. Though accepted as a theme for painting thanks to the artists of the Netherlands, whose depictions of choice delicacies adorned wealthy middle-class dining-rooms, the still life only became a noble—as opposed to merely decorative—genre through the talent of Chardins Later, at the end of the nineteenth century, Odilon Redon invested his many floral compositions with a spiritual significance. Vuillard was not concerned with radically rethinking the genre, and in general approached it experimentally. Thus, while pursuing his studies at the Louvre, between 1887 and 1890 he produced, in tandem with his friend Roussel*, a series

Still Life with a Salad (Nature morte à la salade), 1887–1888. Oil on canvas, 18 x 25 ½ in. (46 x 65 cm). Musée d'Orsay, Paris.

of still lifes in the manner of Chardin, Corot, and Fantin-Latour (*Apple and Wine Glass* [*Pomme et verre de vin*], c. 1888; *Still Life with Salad* [*Nature morte à la salade*], 1887–1888). After seeing Sérusier's* *Talisman*, he broke with Classicism and Chardin's subtle graduations of tone, instead exploring pure color and the quasi-abstract Synthetism of Gauguin* in *The Lilacs* (*Les Lilas*, c. 1890). After a sojourn in Holland in 1902, where he no doubt took the opportunity to view many still lifes, he decided to try his hand at the genre once more. Later, during a somewhat transitional phase, he started on a series of floral subjects in the Flemish manner from which gradually evolves a shift to Impressionism* (*Vase of Flowers* [*Vase de fleurs*], 1903; *Flowers* [*Fleurs*], 1904; *Bouquet of Roses* [*Bouquet de roses*], 1905; *Flowers in*

a Vase [*Fleurs dans un vase*], 1905). Forging a joyous amalgam between Realism* and decorativeness (*Flowers*, 1904), his 1905 works, more faithful to reality, herald a series that would emerge beginning in 1930 at the Hessel's* Château de Clayes. Though evocative of Redon, they are devoid of the mystical atmosphere of that artist's creations. Composed in keeping with the painter's acute aesthetic sensibility, these works amount to a new departure that allowed Vuillard to exploit the absolute Realism that would henceforth characterize his career, in particular by a use of close-up framing (*The Blue Vase*, 1930–1933).

■ Studios

In the twentieth century, art revolutions generally took place in studios that were often transformed into veritable hives of artistic activity—Picasso's Bateau-Lavoir and Villon's workshop at Puteaux being prime examples. In the same way, in 1889, the Nabis* started the pictorial revolution of "Neo-Traditionalism" in the Académie Ranson*, also known as "The Temple." From 1891, it was in the studio of Vuillard, Lugné-Poe*, Bonnard*, and Denis* on rue Pigalle that the Nabis' discussions took place, opening a new era in which painters collaborated in the performing arts. Vuillard, however, did not always feel the need for a studio of his own and was content to use his friends' (*The Anabaptists** [*Les Anabaptistes*], 1923–1937), or his mother's workshop, in which he found inspiration (*Woman Sewing* [*Couseuse*], 1892–1895). Thus, the periods in which he could enjoy the benefits of a workspace of

Jean-Baptiste Siméon Chardin, *Smoker's Case/Pipe and Jug (La Tabagiel Pipe et vase à boire)*, c. 1737–1740. Oil on canvas, 12 ¾ x 15 ¾ in. (32.5 x 40 cm). Musée du Louvre, Paris.

his own were accompanied by unusual experiments, whereas great difficulties beset him when this was not the case. Salomon, a painter and friend of Vuillard who was to marry Annette Roussel, wrote: "Ranson left Paris during the summer of 1890. H proposed that Vuillard, who at the time had no studio, should come and work in his, located in part of the Hôtel of Mme de Montespan at 25, boulevard Montparnasse. Delighted by this heaven-sent opportunity, Vuillard there spent his time painting many works of synthesis (probably *The Goose* [*L'Oie*] and *The Lilacs* [*Les Lilas*]) that unquestionably mark significant turning points in his work." The daring Neo-Traditionalist canvases date from the time of the studio in Pigalle and betray something of Vuillard's new-found interest in the theater* (*In bed* [*Au lit*], *Portrait of Lugné-Poe, Portrait of*

Bonnard, Dinner Time [L'Heure du dîner]). Thereafter, he generally worked in the apartment occupied by his mother, where it was not easy for him to tackle nudes or large-format canvases, though he never abandoned either completely. Although he could concentrate on the nude with greater freedom in the studio he worked in from 1909 to 1926 on boulevard Malesherbes (Interior with Folding Screen [Intérieur au paravent], 1909–1910), when it came to state commissions the artist managed to cope with such adverse conditions brilliantly. In an attempt to mitigate the difficulties large-scale works entailed—to the extent that the artist was unable to visualize them before their installation in the Palais de Chaillot* (1937) and at the League of Nations* in Geneva (1938)—he adopted what was for him a wholly new approach: allegory.

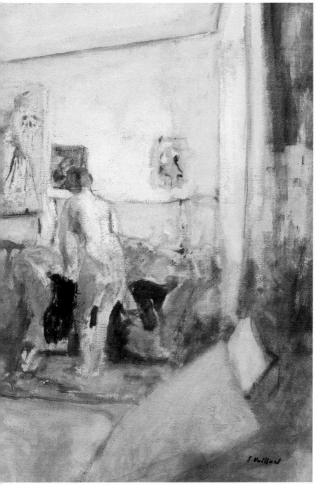

Model in the Studio, Rue Truffaut (Modèle dans l'atelier rue Truffaut), 1903–1904. Oil on canvas, 21 ¾ x 31 ¼ in. (55 x 81 cm). Private collection.

Following page: Interior at the Dressmaker's/The Suitor (L'Intérieur à ouvrage/Le Prétendant), 1893. Oil on cardboard, 12 ½ x 14 ¼ in. (31.7 x 36.4 cm). Smith College Museum of Art, Northampton.

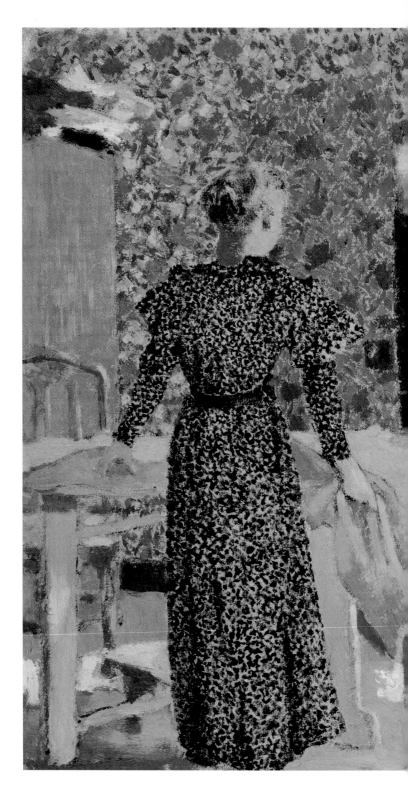

■ Symbolism

Symbolism appeared around 1886 in diverse artistic expressions (literature, poetry, painting, theater*, music), setting itself the task of combating Naturalism—notably that of Courbet, Impressionism*, and Zola. Faced with a real world that they found unsatisfactory, Symbolists fostered an idealistic aesthetics through a suggestive, enigmatic, even introspective language, so as to express the arcane meaning of the external world. Inspired by mythology and early Christian art—if diversely interpreted—Symbolism in France numbered among its painters Puvis de Chavannes*, Odilon Redon, and Gustave Moreau (*The Apparition*, 1876), followed by Gauguin* and the Nabis*. In his study of Gauguin's *The Vision after the Sermon/Jacob Wrestling with the Angel* (*La Vision après le sermon/La Lutte de Jacob avec l'ange*), the critic G.-A. Aurier adduces the principles of the art: a work ought to be "idealist,"

"Symbolist," "synthetic," "subjective," and, in consequence, "decorative" (Mercure de France, 1891). In their rejection of Naturalism, the Nabis* are undeniably Symbolist; yet, for Vuillard, as well as for the more mystically inclined Denis and Sérusier*, the task was not to conjure up symbols or allegories, but to find "plastic equivalents" with the potential "to translate and arouse emotional states" (Denis). With this in mind, Vuillard noted in his journal* for 1891: "My sole desire now is the life of my soul." Though not of a metaphysical bent, Vuillard rejected the slavish aping of nature, committed instead to expressing it through the filter of his sensitivity and intellect. In Puvis de Chavannes, he found a means of shaking off illusionist figuration, and in Redon a method for distilling mystery into his art (*Pillars of Society* [*Les Soutiens de la société*], 1896), cultivating a subjective, suggestive art close to the verse of Mallarmé* (*Scene in a Garden/The Third Class Coach* [*Scène dans un jardin/Le Wagon de troisième classe*], c. 1891). His interiors are filled with the unspoken drama of Maeterlinck's existential vision that had etched itself on his mind (*Dinner Time* [*L'Heure du dîner*], c. 1891). Thus, although he admired the Symbolists highly, Vuillard, in preferring to paint scenes from daily life, never adopted their mystical beliefs. However, it was through his confrontation with these painters that Vuillard was to discover his authentic artistic path: *intimisme**.

Gustave Moreau,
The Apparition,
1876.
Watercolor,
3 ft. 5 ¼ in. x
2 ft. 4 ½ in.
(105 x 72 cm).
Musée du Louvre,
Paris.

▩ TALISMAN, THE
Landscape in the Bois d'Amour (*L'Aven au Bois d'amour*)

"It was following the summer vacation of 1888 that Sérusier*, lately back from Pont-Aven*, revealed to us the name of Gauguin*. Rather mysteriously, he unveiled the lid of a cigar-box on which one could just make out a landscape* that had been treated so synthetically that it had lost all form—in violet, vermilion, Veronese green and other pure pigments, just as they come straight of the tube, without adding white. 'How do you see this tree,' asked Gauguin, standing before a corner of the 'wood of love,' 'is it quite green? Put in some green then, the most beautiful green in our palette. And is that shadow rather blue? Don't be afraid of painting it as blue as possible.' In this way for the first time were we confronted, in a paradoxical yet unforgettable form, with the fruitful concept of the 'plane surface to which colors assembled in a certain order are applied.' Thus we learned that every work of art is a transposition, a caricature, the impassioned translation of some feeling sensation (Maurice Denis, *L'Occident*, April–May 1903). "

To understand why this little picture had such a revelatory effect on Denis*, Ranson*, Ibels, and Bonnard*, then on Vuillard and Roussel*, it must be put into the context of its time. Since they were not invited to official exhibitions, the young painters had, for the most part, never laid eyes on Impressionist works by Renoir, Cézanne, Monet, Degas, or Sisley. Their benchmarks until then had been stalwarts of the Salons, academic artists such as Bougereau and Cabanel. Our fledgling artists, after mature reflection, were bound to adopt Sérusier's *L'Aven au Bois d'amour* as their 'Talisman'—from the Arabic *tilasm* or Greek *telesma*, meaning 'rite' or ' endowed with a magic power.' Adepts of esotericism such as Ranson, Sérusier, and himself, Denis

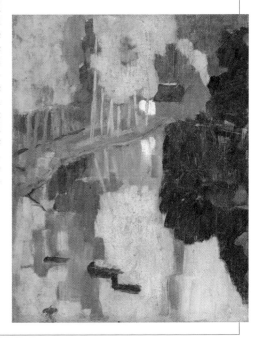

recalled, would have liked to set up a 'secret mystical society.' Although the work is of small size (10.63 x 8.66 in. [27 x 22 cm]), painted on a rectangle of wood, it marked the starting point of Nabism (see Nabis), a movement which, following the lead given by Gauguin, Émile Bernard, and Cézanne, constituted the first step on the path to the autonomy of painting.

Paul Sérusier, *The Talisman/ Landscape in the Bois d'Amour (Le Talisman/ L'Aven au Bois d'amour)*, 1888. Oil on panel, 10 ¾ in. x 8 ½ in. (27 x 22 cm). Musée d'Orsay, Paris.

◼ THEATER

From avant-garde dramas of the late nineteenth century to the light comedies of the first part of the twentieth, the theater constantly stimulated Vuillard's creativity. He helped to decorate the scenery (see Sets and Scenery) for the Théâtre des Marionettes in Ranson's* studio, spontaneous sets with which he would experiment further in Claude Terrasse and Alfred Jarry's Théâtre des Pantins (1896–1898). Introduced in 1890 to the Naturalist Antoine* by Lugné-Poe*, the artist then collaborated at the Théâtre-Libre, before joining the idealist Paul Fort's* Théâtre d'Art, with which he felt greater stylistic affinity. It was, however, within the groundbreaking Théâtre de L'Oeuvre, founded with Lugné-Poe and Camille Mauclair, that Vuillard found his freest expression, creating the lion's share of its programs* as well as some gloriously inventive sets that were to reappear in the more innovative German and Soviet theater companies after 1920.

Through Symbolist (see Symbolism) works that "offer disconcerting parallels with Vuillard's personal situation," in particular in Ibsen's *Ghosts*, a play that recounts the story of a "young painter… sequestered by a domineering mother" (Cogeval, *Vuillard Le Temps détourné*), Vuillard sublimated his bachelor state. It is not hard to find analogies between the omnipresence of printed fabrics in Vuillard's works of this period and that of his mother (a corset-maker!) who shared his life (*Interior/The Artist's Mother and Sister* [*L'Intérieur/Mère et soeur de l'artiste*],

1893), and to sense the pent-up drama in certain family scenes (*Dinner Time* [*L'Heure du dîner*], c. 1891). Acting as a sort of catharsis, Symbolist theater allowed the artist to blossom fully, as can be seen from the clarified, colorful scenes inspired by the stage (*Actress in her Dressing-room* [*Actrice dans sa loge*], c. 1892).

Even after he had ceased collaborating with Lugné-Poe in 1895, the theater remained his principal source of entertainment. From that point on, he designed his pictures like sets, placing his models as a stage designer would. A close friend of the playwrights Tristan Bernard, Pierre Veber, and Raymond Coolus, Vuillard also met stars of the Boulevard—including Sacha Guitry (see *Yvonne Printemps and Sacha Guitry*) and Henri Bernstein— through the Hessels*. Identifying with such comedies, he took Bernard's *Petit Café* as a starting point for the decoration of the Théâtre des Champs-Élysées* (1913), before painting *La Comédie* for the Palais de Chaillot* (1937). In the very Nabis series (1922) inspired by Guitry's *Illusionniste*, Vuillard regained his erstwhile visionary insight. Moreover, the over-furnished sets of bourgeois comedy were rich in material for his own highly detailed and realistic pictures.

Facing page:
Portrait of the Actor Ernest Coquelin Holding his Head in his Hands (Portrait de l'acteur Ernest Coquelin, la tête entre les deux mains).
Watercolor, black pencil and black ink,
8 x 5 ½ in. (20.3 x 13.3 cm).
Musée du Louvre, Paris.
From the Musée d'Orsay collection.

Right:
L'Illusionniste : Gardey the Dwarf in the Wings (L'Illusionniste: le nain Gardey dans les coulisses),
1922. Sketch, distemper on canvas,
5 ft. 9 ½ in. x 1 ft. 7 ¾ in. (176.5 x 50 cm).
Galerie Bellier, Paris.

105

■ Théâtre des Champs-Élysées

The inauguration of the Théâtre des Champs-Élysées in 1913 presented Vuillard with the chance to assert for the first time in a public building his talents as a theater* decorator that he had left off since 1895, and once again to display his fondness for the performing arts. Set up on the initiative of Gabriel Astruc in one of Paris's* smartest districts, the "Palais Philharmonique" was to introduce Parisian audiences to new trends in dance, theater, and music. This ambitious project, unparalleled since the opening of the Opéra Garnier in 1875, would combine the efforts of architects Henry Van de Velde and Gustave and Auguste Perret in a highly innovative construction, particularly in its use of reinforced concrete. Most of the artists took up the Neoclassical spirit of the building in their compositions: Bourdelle adorned the sparseness of the facade with three reliefs, and the lodges as well as the foyer-cum-lobby with mythological frescos; Denis* decorated the cupola of the hall set aside for the lyric arts with panels in the Roman

Set detail for Tristan Bernard's *Le Petit Café*, in the Comédie room at the Théâtre des Champs-Élysées, 1911.

106

style on the theme of music and dance; and Roussel* took Bacchus as inspiration for the curtains As for Vuillard, he was put in charge of decorating a second hall known as the Salle de la Comédie, reserved for the dramatic arts. Swayed by Astruc's approach that corresponded to the unheard-of demands he made of his audiences, Vuillard differed from his fellow artists in taking as his starting point theatrical "hits" of the time. Themes for his panels were taken from Tristan Bernard's *Le Petit Café* (Palais-Royal, 1911), *Le Malade imaginaire* (Odéon),

Pelléas et Mélisande (Opéra Comique, 1902) and *Faust*, with an additional green-room scene (*Actors and Actresses Applying their Face-paint* [*Acteurs et actrices se grimant*]) and two other works, *Guignol* and *Flowers*. These realistic pieces offer further evidence of his development towards a variant of Classicism and to his newfound interest in the type of light comedy in vogue in the bourgeois circles in which he was now moving. In the first two panels, by representing this class of theater-goer observing itself, and by stressing sartorial parallels between the actors and the audience in *Le Petit Café*, the artist—if with tongue in cheek—seems to acknowledge that the world he found so fascinating now formed the theater of his everyday existence.

■ Travels

As his *intimiste* (see *Intimisme*) and Parisian (see Paris) works indicate, Vuillard rarely felt the desire to travel. Circumstances, however, led him to journey to several French regions and in Europe. Rather than mere excursions, these trips generally awakened his interest in some new technique or genre. Thus, after one relatively sedentary period—interrupted at most by a few trips to the Gironde with Redon in 1901, to London in 1889 and Spain in 1901 with Bonnard* and the brothers Bibesco—the artist, now on friendly terms with the Hessels*, began traveling more frequently, accompanying them on all of their expeditions between 1902 and

1914. Receptive to the Impressionists (see Impressionism), he followed in the footsteps of Monet with the Hessels through Normandy (*A Game of Cards in Amfreville* [*La Partie de cartes à Amfreville*], 1906) and that of Boudin (*A Fishing Vessel* [*Bateau de pêche*], 1908–1909), sometimes crossing Gauguin's* paths in Brittany (*The Walk in the Port*, [*La Promenade dans le port*], 1908). This renewed interest in Synthetism, added to the Impressionist influence, resurfaced in the landscapes completed after his sojourns in the harbor cities of Hamburg in 1913 and Honfleur, Normandy, in 1919. If these excursions brought fresh enthusiasm for landscape and for the techniques of its masters, Vuillard's

wanderings occasioned by the war were to make him aware of a reality he had never before experienced. After a brief stay in 1914 at Conflans-Sainte-Honorine, in the Paris area where he worked as a line-guard, he was dispatched in 1917 by the Ministry for Fine Arts as a war artist to the Gérardmer front in the Vosges. The atmosphere exuded by *The Interrogation of the Prisoner* (*Interrogatoire du prisonnier*, 1917) shows that he was very affected by the POW camps, focusing more on the detainee and his weakened state than on the soldiers and the officer whose inquisitorial attitude is brought into stark relief. Meanwhile, his visits to Thadée Natanson's* armament factory resulted in works that

Munitions Factory, evening light. (L'Usine de guerre, effet de soir), 1917. Decoration for Lazare Lévi. Distemper on canvas, 2 ft. 5 ½ in. x 5 ft. ½ in. (75 x 154 cm). Musée National d'Art Moderne, Troyes.

A Corner of the Garden, Saint-Jacut (Coin de jardin, Saint-Jacut), 1909. Distemper on paper mounted on canvas, 19 ½ x 19 ½ in. (49.5 x 49.5 cm). Private collection, Paris.

stressed the tough conditions endured by workmen at the forge or piling up shells (*War Factory, day light* and *evening light[L'Usine de guerre, effet de jour* et *effet de soir*], 1917). The poignant Realism of these pictures, which contrasts pointedly with the safe, secure worlds in which he normally specialized, constitutes a unique experiment.

■ Vallotton, Félix

A friend from another country
Born in Lausanne in the canton of Vaud, Félix Vallotton (1865–1925) trained under a painter in his native Switzerland before being enrolling at the Académie* Julian from 1882 to 1885, and again in 1889. Close to Sérusier*, Denis*, Roussel*, and Ibels, he also met Vuillard, who was to become a lifelong friend. Starting out working in a realistic manner (*Kitchen Interior with Figure*, 1890), he trained in black-and-white engraving until 1900, with the forms becoming increasingly simplified after 1891. He exhibited with the Nabis* in the Barc de

Boutteville gallery in 1893 (*Le Bon Marché, Bather*), before joining *La Revue blanche** in 1894, where he collaborated with Bonnard* and Vuillard—artists possessing affinities in terms of character and taste (for Japanese art, for instance), if divergent in style. As Vallotton himself explained: "I have a taste for synthesis, and subtleties of nuance do not appear in my drawings, nor am I capable of them." Possessing natural talent for printmaking*, the "foreign Nabi" created works that can be described as schematic (*Street Scene in Paris*, 1895), though he also took an interest in the performing arts, later turning his hand to writing. With Vuillard, he participated in the crazy first night of Alfred Jarry's *Ubu Roi* at the Théâtre de l'Oeuvre, and, in 1895, unveiled a project for stained glass (*Parisiennes*) for Siegfried Bing's gallery, La Maison de l'Art Nouveau. After his marraige to Gabrielle Rodrigues-Henriques, daughter of Alexandre Bernheim, in 1899, Vallotton was featured with Vuillard in an 1903 exhibition of their work at his father-in-law's gallery. In 1899, Vuillard joined Vallotton at the château at Étratat, and in 1900 in Romanel, Switzerland, where he set about painting landscapes in a Synthetist style close to Vallotton's (*Landscape with Blue Hills* [*Le Paysage aux collines bleues*], 1900). The Vallottons joined Vuillard at the Natansons'* near Cannes in 1901, then at the Hessels'* at Criquebeuf in 1902. Vallotton continued engraving, tackling new themes including numer-

ous objectively realistic nudes. Teaching together at the Académie Ranson* in 1908, the two artists remained fondly attached: "Received a note from Vuillard. Nothing about him leaves me indifferent; youth passes by, yet there remains the solidity and reason we've acquired" (Vallotton, *Journal*). After the war, a branch of a business in Switzerland run by Félix's brother Paul Vallotton contained several pictures by Vuillard. "Met Vuillard engrossed in a portrait. All our former tenderness for one another came flooding back in a few idle remarks… He stays the same—chic and of fine quality… We knew and appreciated each other when young, and maturity has merely prolonged this happy state in us, in spite of our whitening hair, our sciatica, etc." (Vallotton, Journal).

Félix Vallotton in his Studio (Félix Vallotton dans son atelier), c. 1900. Oil on cardboard mounted on panel, 24 ¾ x 19 ½ in. (63 x 49.5 cm). Musée d'Orsay, Paris.

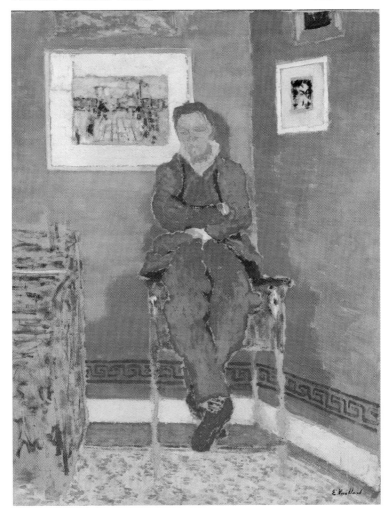

Painted in 1908, following a stay in Pouliguen with the Hessels*, *The Walk in the Port*—hung side by side with *In Bed* (*Au lit*) in the exhibition of the Roussel* donation—undoubtedly created a stir. If the latter picture demonstrated the revolutionary thrust of the Nabis* period, the former called into question Vuillard's image as a Paris *intimiste* (see *Intimisme*) who after 1900 became a Realist (see Realism). Fully committed to this Impressionist* phase (see Impressionism), it was only natural that Vuillard would be drawn to the genre of the marine, as it had been experimented with in an innovative fashion by both Monet and Caillebotte in Brittany. Discovering the region in his turn, Vuillard, crisscrossing paths already trodden by Eugène Boudin and Gauguin*, created something distinctly modern. Dissatisfied with his earlier, photograph-based landscapes (*The Haystack* and *The Tree-Lined Avenue* [*La Meule* and *L'Allée en sous-bois*], 1907–1908) that had lacked brightness, he now followed Boudin's lead and painted over a light beige ground. By not completely overlaying the undercoat only partially submerged beneath transparent, vibrant colors, he attained the sunny, blond effect that is Boudin's hallmark. Distinct from the earlier master's manner, however, the pair of figures gazing at the boats are framed in flat tints of contrasting hue typical of the Nabis and Gauguins Vuillard seems to have been rejuvenated by the sea air, and sought out other harbors (Hamburg and Honfleur), transforming them by a subtle blend of Synthetism and Impressionism. As it remained in a sketched state, the artist probably showed *The Walk in the Port* only rarely. The glaze effect is exceptional: it is a little as if

Vuillard, disturbed by this surge of modernity, had intended to stave off the march of time—be it for only a single second.

Walk in the Port (La Promenade dans le port), 1908. Distemper on paper mounted on cardboard, 25 ¾ x 25 ½ in. (65 x 64.5 cm). Musée d'Orsay, Paris.

■ YVONNE PRINTEMPS AND SACHA GUITRY

ainted in 1922 at the time of Guitry's *Illusionniste, Yvonne Printemps and Sacha Guitry* testifies to Vuillard's unflagging interest in the theater*. In the play, performed at the Théâtre Édouard VII, the actress took the role of Miss Hopkins and the director (here concealed behind a rail) that of the illusionist. Truly inspired by the piece, Vuillard seems to have intended to depict it from all sides, portraying it in production (*Sacha Guitry, de Gardey the Dwarf and his Companion* [*Sacha Guitry, le nain de Gardey et sa compagne*]), offstage (*Yvonne Printemps Seen from the Wings* [*Yvonne Printemps vue des coulisses*]), and,

in all probability, after the show. Concentrating on the actress's radiance and laughter, the painter, as in *The Anabaptists* (*Les Anabaptistes*), portrays figures in their working environment. As Yvonne seems oblivious of the painter's presence, he was able to take his preferred role as the observer. If the theatrical world seems to have encouraged Vuillard to revert to practices dating from the Nabis* period (*Gardey the Dwarf* [*Le Nain Gardey*], 1922), here space and figures are captured with his by now customary Realism. This clever device allows him to impart a rhythm unparalleled in his Synthetic works inspired by the theater—and also

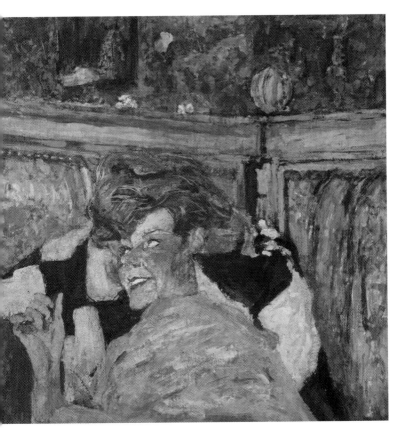

missing from the frequently stiff society portraits he was now turning out for his new patrons. Presenting these richly dressed theatrical models in the opulent world he had himself been frequenting for nearly twenty years, Vuillard achieves an effect far removed from that of the unexceptional, everyday existence of the maternal nest in which he reveled in his early *intimiste* paintings (see *Intimiste*). The painter, however, still chooses to illustrate a shared moment—this time between an actress and her husband. In reuniting with Sacha Guitry, whom he had most likely met at the Théâtre d'Art, and rubbing shoulders with Tristan

Bernard, Henry Bernstein, and Raymond Coolus, Vuillard now turned his attention to the popular stage: he would make good use of this when composing in space the members of the more elevated class whose portraits he was now painting (see Society Portraiture).

Yvonne Printemps and Sacha Guitry, 1919–1921. Oil on paper mounted on canvas, 24 ¾ x 35 ½ in. (63 x 90 cm).

1868 Édouard Vuillard is born on the 11th of November at Cuiseaux in Saône-et-Loire. The son of Joseph-Honoré Vuillard, a captain of the marine infantry turned tax collector, and of Marie (née Michaud), he has a sister, Marie, and a brother, Alexandre.

1877 The family moves to 8 rue Chabrol, Paris. Vuillard attends the school of the Marist Brothers, Rocroy-Saint-Léon.

1881-1884 Vuillard attends the Lycée Condorcet on a scholarship. Roussel, Lugné-Poe, and Denis are his classmates.

1884 Death of Vuillard's father.

1885 The family leaves 20 rue Daunou, where they have been living since 1883, and sets up house at 6 rue Marché-Saint-Honoré. Vuillard leaves Condorcet and joins Roussel at Diogène Maillart's studio, rather than preparing for the entrance exam to Saint-Cyr military school.

1886 He fails the entrance examination for the École des Beaux-Arts and enrolls in the Académie Julian.

1887 Following another failure, he is accepted at the École des Beaux-Arts in July. He attends Robert Fleury's life-drawing classes at the Académie Julian. The family moves to 10 rue Miromesnil.

1888 He spends six weeks studying at the École des Beaux-Arts (in Gérôme's atelier). Starts sketching at the Louvre and keeping a journal. Sérusier returns from Pont-Aven with his *Landscape in the Bois d'Amour* (*L'Aven au Bois d'amour*), which later becomes *The Talisman* for the first group of Nabis (Denis, Ranson, Ibels, and Bonnard).

1890 This was Vuillard's "year of Sérusier"; Denis introduces Vuillard to Bonnard and Sérusier. Ranson lets him use his studio, which is where the Nabis hold their meetings. Creates his first Synthetist and Pointillist works and first contributions of lithographed programs to the Théâtre Libre.

1891 Shares a studio at 28 rue Pigalle with Denis, Lugné-Poe, and Bonnard. Moves with his family to 346 rue Saint-Honoré. Exhibits at the Galerie Le Barc de Boutteville with the Nabis until 1894. Meets Thadée Natanson, founder of *La Revue blanche*. Befriends Coquelin Cadet, an actor at the Comédie-Française and one of his first admirers. Works for the Théâtre d'Art, managed by Paul Fort from 1890 to 1892.

1892 Exhibits at the premises of *La Revue blanche*, and then regularly with other painters. Creates his first decorative panels for the Desmarais. Travels to Belgium, Holland, and London.

1893 Founds the Théâtre de l'Oeuvre with Camille Mauclair and Lugné-Poe, where he designs most of the sets and programs. Death of his maternal grandmother. Marriage of Vuillard's sister Marie to Roussel.

1894 Paints the first of the *Public Gardens* (*Jardins publics*) decorative panels for Alexandre Natanson. Misia Natanson becomes his muse.

1895 Vuillard's tableware and stained-glass window designs for Jean Schopfer (known as Claude Anet) are exhibited at Siegfried Bing's Paris gallery, La Maison de l'Art Nouveau. Paints five decorative panels for Thadée Natanson. Exhibits with the Nabis at Saint-Germain-en-Laye. Stays with the Natansons at Valvins, then at Villeneuve-sur-Yonne from 1897 onwards. Meets Mallarmé.

1896 Moves with his mother to 342 rue Saint-Honoré. Paints *Figures and Interiors* (*Personnages et Intérieurs*), a series of four panels: *Reading*, *The Library*, *The Work Table*, *The Piano*, for Dr. Vaquez. Ambroise Vollard orders albums of lithographs from Vuillard, Bonnard, and Roussel. Vuillard's album, *Landscapes and Interiors* (*Paysages et Intérieurs*), will be published in 1899.

1898 Birth of Annette Roussel, Vuillard's niece. Moves with his mother to rue Truffaut. Begins decorative panels for Claude Anet, completed in 1901.

1899 Decorative panels commissioned by Adam Natanson. Travels to London and Italy.

1900 Exhibits with the Nabis at the Bernheim-Jeune gallery, where he exhibits regularly until 1913. Stays with Vallotton in Switzerland, where he meets Lucie Hessel who becomes his new muse.

1901 Contributes to the Salon des Indépendants regularly until 1906, and then again in 1909 and 1910. Travels to Spain with Bonnard and the Bibescos.

1903 Exhibits at the Salon d'Automne regularly until 1906, and then in 1910 and 1912.

1908 Completes the decorative panels *Streets of Paris* (*Rues de Paris*) for Henry Bernstein and *The Haystack* (*La Meule*) and *The Tree-Lined Avenue* (*L'Allée*) for Prince Bibesco. Moves with his mother to 26 rue de Calais. Spends the summer at Le Pouliguen in Brittany with the Hessels.

1911 Creates his *Place Vintimille* folding screen for the Princess Bassiano.

1912 Decorates the Comédie room of the Théâtre des Champs-Élysées. Paints decorative panels (*The Veranda*) for Bernheim-Jeune's Bois-Lurette villa in Villers-sur-Mer.

1914 Works for the railroad as a line-guard at Conflans-Saint-Honorine, near Paris. Travels to Italy with the Hessels and Romain Coolus.

1917 Paints the Gérardmer military front at Vosges. Goes regularly to Clos Cézanne, the Hessels' house at Vaucresson until 1924. Becomes the portrait artist of Parisian high society.

1921 Over the next year he works on the *At the Louvre* (*Au Louvre*) series.

1922 Creates panels inspired by Sacha Guitry's *L'Illusionniste*.

1923 Begins work on the *The Anabaptists* portraits series, which he completes in 1927.

1926 The Hessels leave Clos Cézanne and buy the Château de Clayes, near Versailles, which will inspire many of Vuillard's works.

1927 Moves with his mother to 6 place Vintimille.

1928 Death of Madame Vuillard.

1934 Temporary lecturer at the École des Beaux-Arts. Travels to London, Deauville and Venice.

1936 Contributes to the retrospective "Painters of *La Revue blanche*", organized by Colette Natanson and held at Paul Rosenberg's.

1937 Paints *La Comédie* for the Palais de Chaillot. Refuses to accept the Légion d'Honneur. Elected member of the Institut de France.

1938 Retrospective at Berheim-Jeune's gallery. Retrospective at the Pavillon Marsan of the Louvre. Paints *Peace Protecting the Muses* (*La Paix protectrice des Muses*) for the League of Nations in Geneva.

1940 Vuillard dies on the 21st of June at La Baule, with Lucie Hessel close by.

SELECTED BIBLIOGRAPHY

Aitken, Geneviève. "Les peintres et le théâtre autour de 1900 à Paris." Thesis, l'École du Louvre, 1978.

Alexandre, Françoise. "Édouard Vuillard, Carnets intimes". Thesis, Doctorat d'État, Université de Paris VIII, vol. I, II, III, IV. Bibliothèque de l'Institut de France, 1997–1998.

Antoine, André. *Memories of the Théâtre Libre*. Miami: University of Miami, 1964.

Bonnard, Pierre and Édouard Vuillard. *Correspondances/Bonnard, Vuillard*. Edited by Antoine Terrasse. Arts et Artistes series. Paris: Gallimard, 2001.

Cogeval, Guy. *Vuillard: Post-Impressionist Master*. New York: Harry N. Abrams, 2002.

Fort, Paul. *Mes Mémoires: toute la vie d'un poète 1872–1943*. Paris: Flammarion, 1944.

Frèches-Thory, Claire, and Antoine Terrasse. *The Nabis*. Paris: Flammarion, 1990.

Lugné-Poe, Aurélien. *La Parade I, Le Sot du Tremplin: Souvenirs et impressions du théâtre*. Paris: Gallimard, 1930.

Lugné-Poe, Aurélien. *La Parade II, Acrobaties: Souvenirs et impressions du théâtre*. Paris: Gallimard, 1931.

Makarius, Michel. *Vuillard. Masters of Modern Art* series. New York: Universe Books, 1989.

Preston, Stuart. *Édouard Vuillard*. New York: Harry N. Abrams, 1972.

Roger-Marx, Claude. *Vuillard, His Life and Work*. New York: AMS Press, 1977.

Salomon, Jacques. *Vuillard*. Paris: Gallimard, 1968.

Sert, Misia. *Misia and the Muses: The Memoirs of Misia Sert*. New York: J. Day, 1953.

Sérusier, Paul. *ABC de la peinture*. Paris: Floury, 1950.

Thomson, Belinda. *Vuillard*. New York: Abbeville, 1988.

Vuillard, Édouard. *Souvenir du peintre Édouard Vuillard*. Bibliothèque de l'Institut de France, 1888-1940, vol. I, II, III, IV.

Warnod, Jeannine. *Édouard Vuillard*. New York: Crown Publishers, 1989.

Exhibition Catalogs

Beyond the Easel: Decorative Painting by Bonnard, Vuillard, Denis and Roussel, 1890-1930. New Haven: Yale University Press, 2001.

Bonnard, Vuillard, Roussel. Brussels: Musées Royaux des Beaux-Arts de Belgique, 1975.

Édouard Vuillard, K-X Roussel. Paris: Réunion des Musées Nationaux, 1968.

Édouard Vuillard. New Haven: Yale University Press, 2003.

I N D E X

Photographic credits:
Bibliothèque Nationale de France, Paris: 86; Bridgeman Art Library: 6, 16-17, 43, 44, 60, 61, 67, 68-69, 71, 114-115; Flammarion Archives: 13, 28, 30, 31, 34-35, 36, 39, 52, 65, 90; Galerie Bellier, Paris: 40, 50-51, 88, 105; Galerie Schmit, Paris: 20, 98-99, 110; Magnum/Erich Lessing: 37; Musée des Beaux-Arts, Nice: 93; National Gallery of Art, Edinburgh: Salomon Archives: 8, 9, 15, 19, 55, 56, 73 top, 91;74; United Nations: 54; Réunion des Musées Nationaux: 4-5, 11, 21, 22, 25, 26-27, 29, 32, 45, 46-47, 53, 58, 64, 72, 73 bottom, 79, 80-81, 82, 85, 87, 89, 95, 96, 97, 102, 103, 104, 108-109, 111, 112-113; Rochester, Memorial Art Gallery: 57; Samuel Josefowitz Collection, Lausanne: 10, 24, 33, 48-49, 62-63, 77, 83; Smith College Museum of Art, Northampton:75, 100-101; Société Immobilière du Théâtre des Champs-Élysées, Paris: 106-107

Title page: *Self-Portrait. Study of a Face (Autoportrait, étude de visage)*, c. 1889. Oil on canvas, 9 ½ × 7 ½ in. (24.5 × 19 cm). Musée d'Orsay, Paris.

Pages 4–5: *Under the Lamp (Sous la lampe)*, 1892. Oil on canvas mounted on panel, 14 ¾ × 18 in. (37.5 × 45.5 cm). Musée de l'Annonciade, Saint-Tropez.

Acknowledgments
Sincere thanks to Catherine Laulhère-Vigneau, Nathalie Bec, Sandrine Bailly, and Anne-Lou Bissières; Arnaud D'Hauterives, permanent secretary of the Académie des Beaux-Arts; Mireille Pastoureau, head librarian of the Bibliothèque de l'Institut de France; Famille René and Paulette Gaultier; Famille Henri and Micheline Lamirand; and Maria Landau, Karim A. Soumaïla, Cloé Fontaine, Orazio Massarro, Huez Mathieu, Linda Pastoriza, Sarah Mennecier, Ellen Knibe, Fabrice Cérézales, Sandrine Chollet and Sergio Giral.

The publisher would like to thank Matthias Chivot at the Salomon Archives, Samuel Josefowitz, Robert Schmit, Galerie Bellier, Aneleen de Jong at the United Nations, and Eugenia Goridi Esmeraldo at the Art Museum of São Paulo for their invaluable assistance.

Translated and adapted from the French by David Radzinowicz
Copy-editing: Lisa Barnett
Typesetting: Anne-Lou Bissières
Proofreading: Brian Smith
Editorial assistance: Emma Harris
Color Separation: Pollina, S.A., France

Simultaneously published in French as *L'ABCdaire de Vuillard* © 2003 Flammarion
English-language edition © 2002 Flammarion

ISBN: 2-0801-1092-6
FA1092-02-XII
Dépot légal: 12/2002
Printed and bound by Pollina S.A., France - n° L88038A